Film Actors
Volume 18
FREDRIC MARCH
Documentary study

Part 1

ISBN-13 : 978-1512392494
ISBN-10 : 1512392499
Copyright©2012-2014 Iacob Adrian
All Rights Reserved.

Notice

This documentary study use historic, archived documents.

Because of this, some pages may look blurry or low quality.

Still are included in this book because they have

high value from critical, documentary, historical,

informative and journalistic point of view .

Dtp and graphic design

Iacob Adrian

Copyright©2012-2014 Iacob Adrian
All Rights Reserved.

Author statement

The actors and actresses are the the bricks .

The cast and crew are the plaster .

They stand on the foundation created by producers and writers and directors .

All these people creates the great palace of the art of film .

Iacob Adrian - 2013

This little Book conveys the greetings of

..

to

..

Can a Woman Love

Miriam Hopkins answers a question that confronts every woman sometime in her life

by MIRIAM HOPKINS
as told to
Gladys McVeigh

"When you say 'love,'" declares Miriam Hopkins, "you are toying with one of the most abused words in the English language. Too much, I believe, the perfect love of a past age has become the sex attraction of a later age"

PRIMITIVE POLYANDRY, which in simple terms is the curious ability of one woman to love two men with equal intensity, belongs to an epoch of the past, yet harking back through the ages, every woman (even as you and I) at some period in her life has had to answer this burning question.

Secretly and perhaps instinctively, certain daring feminine spirits have sought an answer to their curiosity, paying dearly for their inquisitiveness in primitive days no doubt, with busted skulls, and in later times with social ostracism and disgrace.

I suppose the reason I was nominated to talk about this interesting question, is because of my recent screen performance in *Design for Living*, wherein as an ultra-modern young woman I find myself in the polyandrous rôle of being hopelessly in love with two men, Gary Cooper and Fredric March.

● Polyandry is nothing new. It has been practiced in the past with respect, and in fact still flourishes among some of the dark tribes today, where the population is predominantly male and where women-folk necessarily must be protected from elemental nature.

If our more primitive sisters indulged in it because of necessity, the women of today have renewed the idea through asserting their own inclinations.

Today women have power, that is the right to vote, to earn their own living. They are self-sustaining and they want to compete with men in all departments. The notion that women are monogamists by nature and that men are polygamists is ancient and outworn.

When the hausfrau was little above the plough horse all was serene, but now she wants the same freedom in love that she has been allowed to enjoy in all other social activities. She has been recognized as man's equal and demanded a recount as it were. In addition to her other accomplishments she feels the glorious privilege of having some choice in the selection of her life mate, yet despite all that has been said about her I believe we still find her fundamentally "woman," with a fine sense of instinctive exclusiveness.

There is little doubt that the spectrum of love includes a multitude of ingredients. As a beam of light passes through a crystal prism to break itself into a myriad of color, so I sometimes consider the personalities of men as varying in their intensity as the rays of a light.

The contrasting qualities of two men might be so varied that I might say, "Yes, I feel an emotion akin to love for each of them. Gary for his sympathetic understanding . . . or Fredric for his mental brilliance." But wait . . . do not mistake me—that is not love in its complete sense.

● When you say "love" you are toying with one of the most abused words in the English language.

Historically speaking, love had its advent into the world some 3,000 years ago. During the sultanesque reign of

Two Men at the Same Time?

Solomon, in an epoch more frankly unmoral than any of which history has cognizance, a native girl of Shulam dared express her preference for an unknown shepherd boy to a monarch in all his splendor and gave us *The Song of Songs*. It is the first evangel of the heart.

This age-old questing by women, undoubtedly has been due to something more fundamental than mere gnawing curiosity. Unquestionably, it had its mainspring in a seeking, a blind sort of groping for perfection in man.

When a woman finds this ideal blending of qualities and characteristic in man her curiosity is satisfied and we find love.

He is the vase to hold the quintessence of her own ideals. She is blind to all but her lover. She wants nobody else. Their compliments seem flat and banal to her. She becomes forgetful of self and desirous only of pleasing her adored one. That is why I do not believe a woman can truly love but one man at a time.

History records many instances where women have perished nobly for the man to whom they have given their heart—but can you imagine, dear reader, two men being the cause of so great a sacrifice?

Too much I believe has the perfect love of a past age become the sex attraction of a later age. There are those who wish to arrange their relationship on a comfortably prosaic level without any high strung pretense of sentimental love.

To reduce love to such a cold unimpassioned routine is to miss the possibilities of a deep, enduring passion.

All women at some critical moment in their lives have wondered—what is the supreme happiness?

For some it is the love of fame and fortune. For others the love of a child.

When I first came to Hollywood, although I was tre-

Please turn to page fifty-three

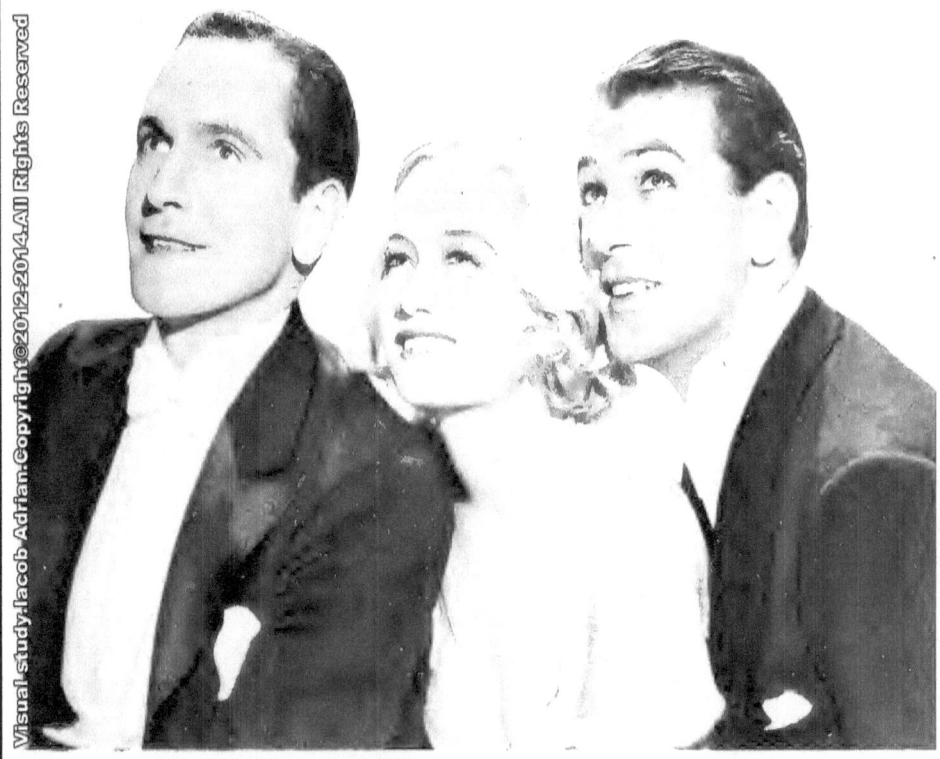

Fredric March, Miriam Hopkins and Gary Cooper in the picturization of Noel Coward's *Design for Living* work out an interesting problem in polyandry. Polyandry is nothing new but the notion that women are monogamists by nature and that men are polygamists is ancient and outworn, Miriam says

FEBRUARY, 1934

Can a Woman Love Two Men at the Same Time?

mendously absorbed with my career, I felt a distinct feeling of loneliness. There were those who wondered how I could possibly feel lonely living such a busy life. Yet it was not complete.

I adopted my infant son Michael, who gives me no end of happy hours after I have finished at the studio. Yet, I feel qualified to say, all of these things do not fill the sustaining rôle of a man's love in a woman's life.

If for a time I should find myself wavering between two masculine admirers of equal charm, it would be a question of time when by an interesting process of elimination I would be able to decide which one I preferred. To complete ourselves women need to be equalled in strength and power of will.

THERE ARE MOMENTS when I feel as though I were getting a panoramic view of the ever-shifting love-life of Hollywood. In fact the newspapers of today in almost any city, tell us of the lovers of yesterday, clamoring wildly for their freedom today.

The wisdom I have garnered from practical observation of my friends and others, leads me to believe that divorce is not always the cure for those of our roaming Romeos and Juliets who are still gifted with an unholy curiosity for the opposite sex.

Surely a woman should feel free to have men acquaintances as well as women. However, I do not mean the promiscuous sort of friendship with her husband's or sweetheart's best friend.

True it is that divorce is no longer a disgrace and busted skulls are out of date. But danger lies in the fact that the issue presents itself as an adventure—a peek beyond. The old idea that the grass on the other side of the fence is always the greenest.

After divorce these same people find themselves in a duplicate situation where similar problems arise.

In marriage there should be the greatest consideration for one another. I have often thought that if married people extended the same courtesy to one another that they do to their week-end house guests, they would be delighted to see how well it would work out.

The often quoted expression "Love is sacrifice" is only partly true, but sacrifice seems to be an essential ingredient in the magic alchemy of love.

What does it matter to a woman if she sacrifices many of the material luxuries of life, if she is happy in love?

For a woman I sincerely believe real love strikes much deeper than an enthusiastic emotion nurtured by flattery and many men.

♦

Tommy's Coming Back

THOMAS MEIGHAN, who once rated a fan following as large as that of any other male star, has returned to Hollywood to consider screen offers. Tommy still is a rich man, but he is tiring of idleness—and golf. He says he'll be content with featured rôles in the future.

FEBRUARY, 1934

SYLVIA SIDNEY
and
FREDRIC MARCH
in Paramount's
"GOOD DAME"
B. P. Schulberg Production
Max Factor's Make-Up
Used Exclusively

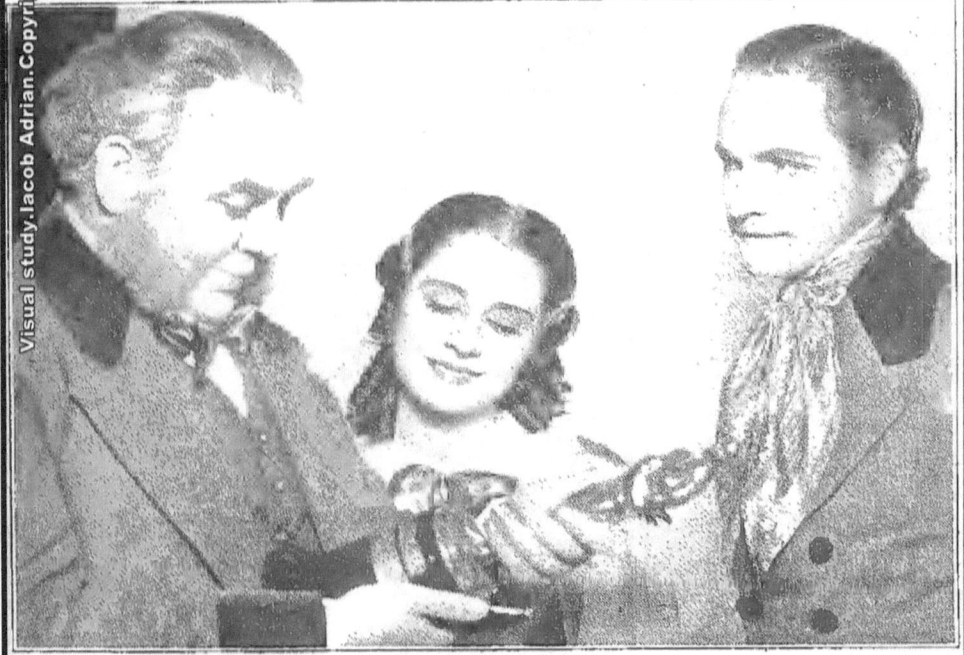

—*Wide World*

Charles Laughton admires the Academy award for the most outstanding screen performance of the year, while Norma Shearer and Fredric March, winners of the coveted prize in other years, look on

* * * because Fredric has achieved phenomenal popularity in such widely diversified rôles as *Dr. Jekyll and Mr. Hyde*, *Death* and the poet *Robert Browning*; because Anna, child of the steppes, electrified America as *Nana*; and because they are co-starred in *We Live Again*

Anna Sten AND Fredric March

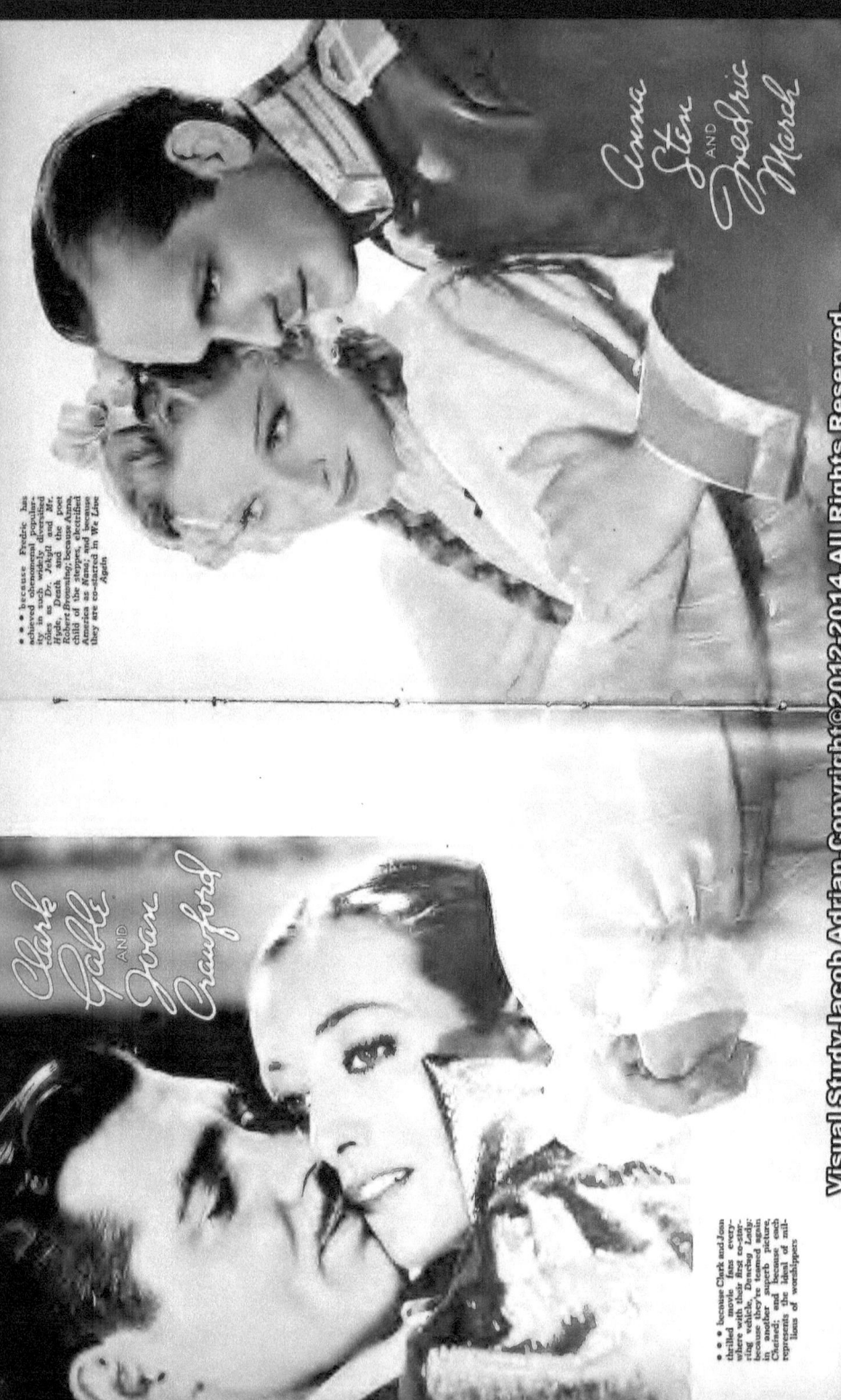

MY LIFE as JOHN BARRYMORE

by *Fredric March*

... who reveals, amusingly and for the first time, what it has been like to be John's "audacious ghost"

THIS IS THE sort of story that, like murder, must out sometime. Yet it is not easy to tell. Some of the old sense of uneasy guilt creeps in, and I feel again that shiver of apprehension that went over me the night John Barrymore sat in the audience and watched me, his audacious ghost, romp through *The Royal Family*.

It seems safe enough now to admit in public print that "The Royal Family" was, of course, the Barrymores, but habit imposes its constraint upon even that admission, for we were used to dissembling with the utmost effrontery when charged with that natural supposition.

Nor have I confessed, until now, the amazing hold that John Barrymore's dynamic personality exerted upon me, and how dangerously close I came to being his pale ghost throughout my screen career. At times it was a sheer tug of war between my own personality and his, which I had grown into through the long assumption of his mannerisms for the stage and screen productions of the parody. It was a tussle as perilous as the one waged between the ego and *alter ego* of *Dr. Jekyll*.

Even today, during a scene requiring intense mental concentration, I slip unconsciously back into that character I wore so long, and discover myself walking with that swinging Barrymore slouch, tugging at my chin and making that lithe, abrupt turn that I studied hard to achieve—and bring up with the sudden realization that Fredric March has not yet escaped from the fellow. It is a strange sensation!

● When *The Royal Family* was to be produced on Broadway, Jed Harris offered me the part, declaring it was just the thing for me.

Unfortunately, Mrs. March and I had just signed with The Theatre Guild to go on tour. We were both brokenhearted, for the play appealed to us strongly, and I hated to miss this splendid chance. However, a mutual friend, George S. Kaufman, the playwright and co-author of the play, who knew the spot we were in, explained matters to Harris.

A year later we saw the play on Broadway, and fairly wept over the fun we had missed. I had a contract to play in Denver, and we came out to Hollywood on a trip a few weeks before the engagement was to begin. I learned that Fred Butler was going to produce *The Royal Family* for a Pacific Coast tour, and went to see him. Again it seemed as if Fate were conspiring to keep me out of a rôle I was obsessed with playing, for my Denver engagement interfered with his plans.

To begin with, Fredric March bore a resemblance to John Barrymore. And his "knack for mimicry" did the rest . . .

The late Paul Bern wrote me in Denver to keep me posted, and urged me to come back to look into the talking pictures situation, which was developing rapidly, before going on to New York. And it so happened that Butler delayed his production until August. At last I was to be John Barrymore. I let my hair grow and developed a mustache, and the play opened in San Francisco to a packed house.

● I had studied all the films and photos of John Barrymore I could find, I had seen him in *The Tempest* and witnessed two performances of his magnificent "Hamlet," and, having a knack for mimicry, I managed to catch the flavor of his walk, speech, and mannerisms.

Please turn to page sixty

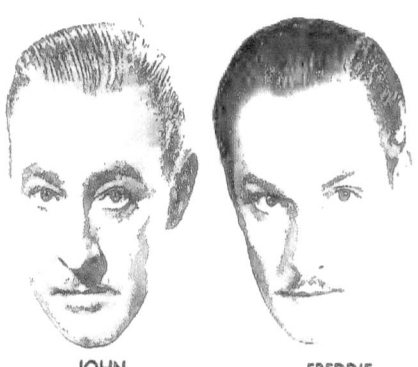

JOHN FREDDIE

MARCH, 1935

My Life As John Barrymore

Actually, Barrymore was easy to caricature. We had a fine cast, and all was going well for us in San Francisco. Picture people were coming up to see football games, and they brought back news of the play's success. Robert Leonard of Metro, up for a game, saw me and arranged a screen test. It must have been pretty bad, for no murmur of interest followed that brief appearance before the camera.

Then the play came down to Los Angeles. Our workout had polished the rough edges and the entire cast was in fine fettle. The play was hailed with delight, and night after night we would spot nabobs of the picture industry out in front.

One evening the big negro doorman came back to my dressing-room.

"John Barrymore, he's out front, suh," he said. "Jus' thought you'd like to know."

The long-dreaded moment had arrived. Barrymore was to see his ghost face to face—and anything might happen! I quaked in my boots, as I thought of the lines, the crackling, profane lines—not to mention my cavorting and high jinks as I took liberties with the greatest figure of the stage and screen. I felt like a small boy at last caught with the cookie jar.

All during the play, I had the funny feeling that Barrymore might rise at any moment and take a pot shot at me. I made my first entrance, as the doorman described it later, "shaking like an aspirin."

I had heard that John's sister, Ethel, objected strenuously to the parody, but that John took it all in good humor and was a regular guy. Nevertheless, I had my misgivings.

The curtain went down. I was still alive. Then the manager burst into my room.

"Barrymore," he gasped, "is in the lobby. And he's laughing! He and his wife are both laughing!"

I sat down and weakly mopped my brow.

Barrymore had known Miss Emelie Melville, the delightful elderly lady who played the mother rôle. A veteran of the stage, she had given a crisp portrayal that was a major contribution to the success of the play. John Barrymore came back to visit in her dressing-room, and sent for me.

By this time I had taken heart and managed to face him without falling down. He cocked his head at me in keen appraisal, suddenly clapped me on the back and broke into roars of laughter. Pacing up and down in the manner I had tried so faithfully to copy, he declared that it was a splendid performance and that he could hardly have done better with it, himself!

You may well imagine my gratitude and relief.

Paramount decided to take a chance on me, and I signed a contract. But having no test of me, and being rather fearful of what I might look like sans mustache and sans long hair, they did not dare remove these adornments. I had to play the part of a young husband in my first picture, still wearing my Barrymore get-up.

Cast in *The Studio Murder Mystery*, I induced them to let me trim my hair. But the mustache, and the Barrymore swagger, remained. I could not for the life of me throw off what had become a habit. Eventually, I gave up the struggle. But the mustache bothered me, for I had always been clean-shaven on the stage. One day I went to the director of *Paris Bound*, which was getting under way at Pathé, and suggested casually that the rôle I was to play would hardly require a mustache. He shrugged and told me to do as I wished, and I dashed for a barber chair as fast as I could, figuring that he would have to take the rap for the consequences.

I was sent East by the studio to do *Laughter* and then *The Royal Family of Broadway*. Walter Wanger was enthusiastic over this picture version of the play, and I had found it simple to slip back into the Barrymore character. Of course, to my way of thinking the play, lost much when it lost its delightful profanities in the picture version, but it went well in the larger cities.

Jesse Lasky called me in.

"This will be your big year," he predicted.

"Well, that rather depends on what parts I get to play," I said.

"What would you like to do?" he asked.

By This Time I rather enjoyed being John Barrymore. Certainly I could not be putting my feet down into more famous tracks.

"Well, any good Barrymore play would be fine," I said. "Such as *Beau Brummell, Dr. Jekyll and Mr. Hyde*—"

"Fine! We own that," said Lasky. "We had thought of selling it, but I think it will do splendidly for you. It was a great success with Barrymore."

We made the picture, with Miriam Hopkins, and if Barrymore ever saw the film, it must have given him a start.

At this time David Selznick called on me for a heart-to-heart talk. He told me quite frankly that I was in danger of losing forever my own personality if I continued my life as John Barrymore. I, too, had been uneasy on that score, and it was then that I seriously attempted to cast off the mannerisms I had assumed for professional purposes.

Unhappily, I had become saturated with these rôles and with these mannerisms so closely identified with John. I had come to feel that I knew him better than his own shadow. But I made the attempt.

I had even taken to wearing Barrymore collars, and now I tried to grow accustomed to a different style. I told myself: "It's time you stood on your own feet; come now, March, and snap out of it!"

Then I encountered my patron again. It was at the Mayfair that John Barrymore strolled up to me, shook hands, and complimented me on my performance as Barrymore.

"They'll have me doing imitations of you before I'm through," he chortled. "Do you know that my daughter has sent for a picture of you and that you are her favorite actor?"

We Laughed Together over that incident, and I felt more in his debt than ever. I wondered if I could be that magnanimous in his place! As I continued in my picture work, I strove more and more to bring my own personality back to its former vigor. A series of costume pictures— *Death Takes a Holiday*, *The Affairs of Cellini*, *The Barretts of Wimpole Street* and *We Live Again*—did not make the task easier. But viewing each one critically, I saw but a faint tracery, now and then, of the old mannerisms, and these fitted the rather swashbuckling rôles portrayed.

Now that I am to do *Les Misérables* in my new contract with 20th Century, I return to an earlier hero in my life—Victor Hugo, and the last fine threads that may still bind me to my life as John Barrymore will snap. I shall be a Victor Hugo character instead, and bring to life the character I revelled in as a boy, when those thick tomes of Hugo's used to weigh me down as I carried them about with me. Oddly enough, my first New York stage appearance was as Victor Hugo in the play, *Deburau*. It was just a walk-on bit, but what a thrill it was!

That is the end of the story of how I was John Barrymore. To that fine actor and great gentleman, I am indebted for his generosity and forebearance, and I, his erstwhile ghost, wish him a long life and a happy one!

—*Wide World*

Joan Blondell, who used to be a dancing daughter, is now a dancing mother. And pretty happy about it, too—as is hubby George Barnes. She'll soon be back on the screen—dancing

NEWS-PHOTO SCOOP OF THE MONTH!

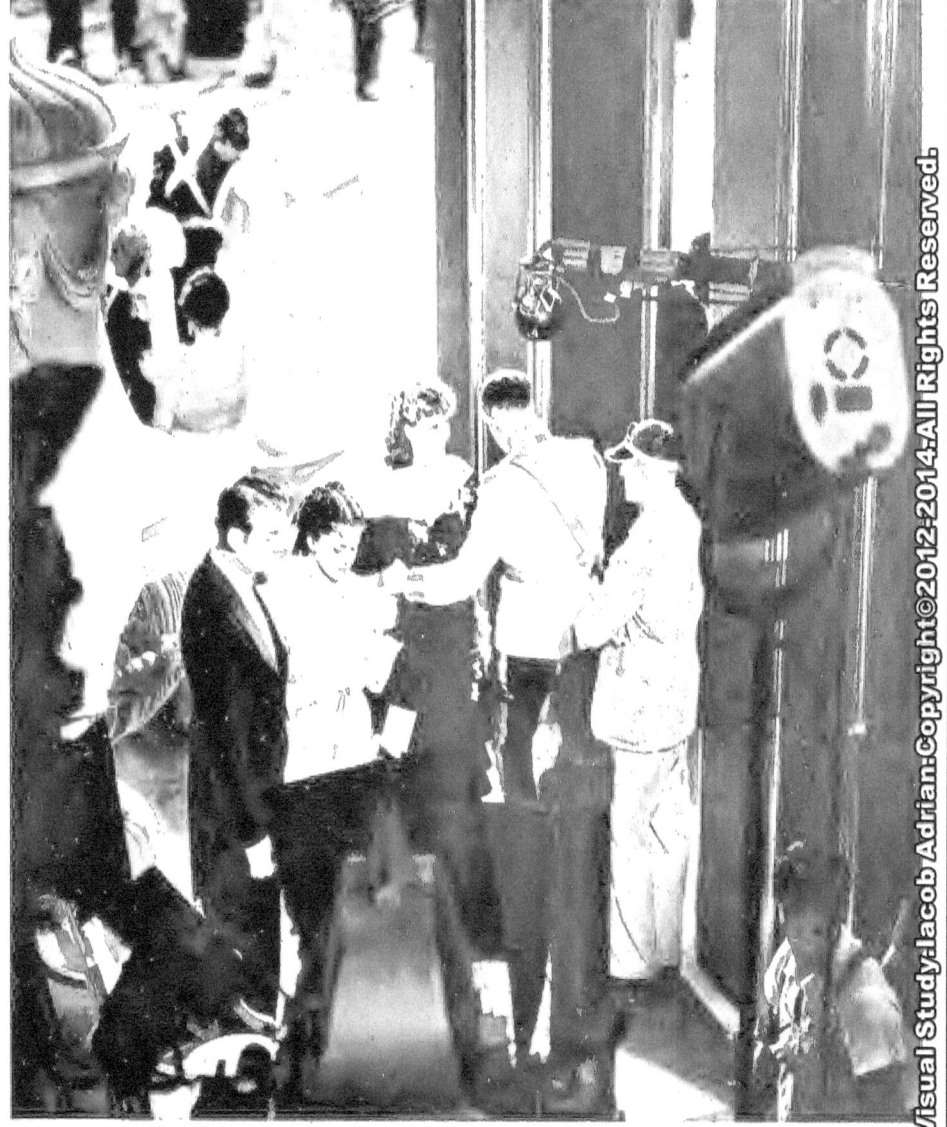

A Stolen Snapshot of Garbo and Freddie March

- Persistent rumors in Hollywood that Garbo and Fredric March were at sixes and sevens with each other during the production of "Anna Karenina" seem to be completely disproved by this candid camera shot—the first ever taken—behind the locked doors of the Garbo set.

Here Garbo is laughing gaily with March as he takes her in his arms for a rehearsal of a ballroom dancing scene. Behind March stands dance director Chester Hale, expert on mazurkas. Note that all the other players carefully refrain from looking at Garbo, who detests curious stares.

Garbo recently visited a night club (Cafe Trocadero) where she enjoyed herself hugely but ran from cameramen. Following her vacation in Sweden she returns to make at least two more. M-G-M pictures for a half million dollars, not one penny of which will be spent foolishly.

AUGUST, 1935

Greta GARBO
Fredric MARCH

Anna Karenina

"ALL THAT I KNOW...I KNOW BY LOVE ALONE"

The heart of a man called to the heart of a woman. "We love", it said, "and love is all." Heart answered heart. With eyes open to what she was leaving forever behind her, she went where love called...to dark despair or unimaginable bliss. It is a drama of deep, human emotions, of man and woman gripped by circumstance, moved by forces bigger than they—a great drama, portrayed by players of genius and produced with the fidelity, insight and skill which made "David Copperfield" an unforgettable experience.

FREDDIE BARTHOLOMEW
(You remember him as "David Copperfield")

with MAUREEN O'SULLIVAN
MAY ROBSON · BASIL RATHBONE

CLARENCE BROWN'S
Production

A Metro-Goldwyn-Mayer Picture... Produced by DAVID O. SELZNICK

When FREDRIC MARCH Got Spanked

It was a long trail down to the woodshed, but that's how this romantic star moved toward fame!

by BARBARA BARRY

Up The Shady street, of a summer's afternoon, flounced Miss Elmira Trott (the name will do as well as any other). Mad as "hops" she was. And —sniff!—good reason, too!

One hand clutched a black umbrella, and the other, the reasonably clean ear of a grotesquely attired youngster who squirmed protestingly at every step.

Pausing only long enough to renew her grip on the unhappy young gentleman's ear, Miss Trott turned up the walk leading to a modest residence, and, resting her umbrella against the porch rail, she turned the bell imperatively.

"Missus Bickel!" she announced acidly to the woman who appeared in the doorway, "somethin's got to be done! This young 'un of yours was apin' me agin, just like t'other day! Right across from my own house he was paradin' flippin' and twitchin' that Sunday black silk o' yours ... bold as brass! I ain't goin' to stand for it, Missus Bickel. I don't have to, and I won't!"

"Freddie!" Missus Bickel eyed the bedraggled Sunday black silk, tangled dustily about the feet of her obstreperous offspring. She wasn't surprised. Freddie had been dragged home before—and by bigger and better citizens than Miss Trott. Punishment seemed useless but....

"I'll tend to him!" she promised the indignant lady (?). "Freddie! Come in here!" and, reaching out, she relieved Miss Trott of her handful of ear.

● Grimly, She Marched our apologetic Freddie down the familiar path to the woodshed.

"I'm sorry, ma . . . Aw, gosh, ma . . . we was just havin' fun!"

"Fun!" the woodshed door slammed behind them with an unrelenting bang. "You've ruined my Sunday black silk! ...I'll teach you to 'ape' folks ...!"

But Freddie Bickel—Freddie March, to you—didn't have to be taught. The art of mimicry was a natural gift. A gift that was, in later years, to win him an award from the Academy of Arts and Sciences for a masterful bit of 'aping' in *Dr. Jekyll and Mr. Hyde*, and put his name at the very top of the movie roster.

However, the harassed Missus Bickel could hardly be expected to recognize budding genius in the apparently incorrigible Freddie. Sunday black silks were few and far between, and the woodshed interludes became more and more frequent.

But, our hero didn't mind too much. One becomes more or less calloused, after a certain amount of punishment. And spinach is [Continued on page 54]

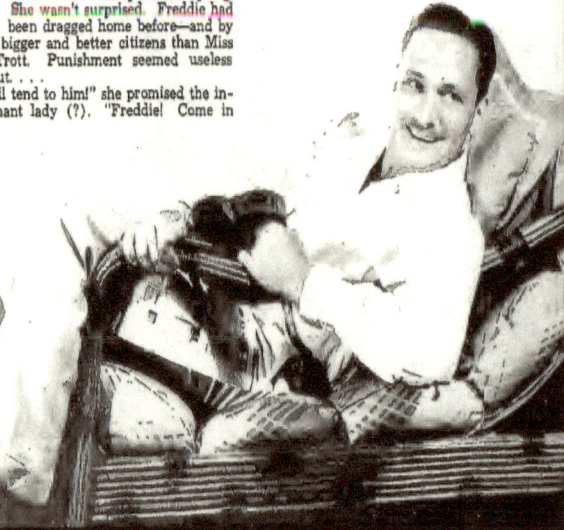

Believe it or don't, the angelic-looking lad at the top left is Freddie March at an age when he was the rowdy-dow of Racine, with Papa Bickel on the right. Center, Merle Oberon, Herbert Marshall and Freddie demonstrate how to be bored with one another on the set

When Fredric March Got Spanked

spinach, whether you eat it at the family table, or off the mantel piece.

One local character, however, was not included in Master Bickel's repertoire of hilarious "take-offs." That was the town banker. And Freddie spared him, only because he had a wholesome respect for bankers, in general. That was at a time when the majority of them were more or less deserving.

"My original ambition was to be a banker," he told us, as we sat in his super-colossal (on a small scale) portable dressing room, between scenes of *Anthony Adverse* at Warner Brothers. "That looked like the best bet in the world. Lots of money, a black silk dress every day in the week for mother, and nothing to do but sit in a fancy office and count one hundred dollar bills!"

Some fun, eh, kid? And, who wouldn't? The idea of acting, as a profession, never entered his head. Actors, as Freddie saw them, were a pretty shabby lot. The traveling stock companies and tent shows that made his home town, presented an array of dubious talent that failed to inspire his adolescent soul.

From the cadaverous "heavy" to the leading lady of indeterminate vintage, they all looked hungry. So, the glamour of footlights and grease-paint left him quite cold.

● BANKERS WERE, without exception, well fed and prosperous looking. Furthermore, they didn't have to travel all over the country playing one night stands to insolvent customers for "coffee and".

No—the fancy office and one hundred dollar bills still comprised the pot of gold at the end of Freddie's rainbow.

Off he went, then, to study the finer points of dividends and compound interest, at the University of Wisconsin.

He must have been what is genially referred to as a "filthy grind," for, in no time at all, the smarty ran away with a scholarship that entitled him to one year's training in a New York bank.

With the local paper carrying a glowing account of the brilliance of their "native son," a few of his early "victims"—who had predicted that Freddie would surely end his juvenile life of crime on the gallows, no less—were plenty red in the face!

Arriving in the wicked city, full of ambition (and the box lunch Mother Bickel had put up for him!) Fred set to work with characteristic determination.

At the bank, they put him behind a barred window, told him briefly what he was to do, and then promptly forgot all about him.

● DAY AFTER DAY, he made little marks in big books; cashed fat checks for thin men; and ran for the scissors whenever the president felt in a mood to clip coupons. And thus the year wore on.

"I didn't seem to be getting anywhere," he deplored. "Just a glorified cashier—that's all I was. And there was nothing I could do about it. So—I stuck. Would have been 'stuck' yet, probably, if, one day when things looked most hopeless, they hadn't carted me off to the nearest hospital and almost permanently balanced my account by carving out the March appendix. That was the turning point in my life."

Lying in the hospital, Freddie had a good chance to think things over.

Life, he decided, was full of a color and excitement that the embryo banker must ignore. Work—and more work. That was the order of things. Burn the midnight oil, lad. Subdue the fever in your blood. And, by the time you're sixty, you'll have money in your own bank and gout in your dancing feet!

"Not for me!" Freddie cried gaily. And, turning in his bob-tailed nightie, he walked out of the hospital and into the nearest stage door.

That was the beginning. Today, he stands on a nice little spot all his own—a grown-up little boy who still gets his just desserts for "apin'" folks. Although it's a far cry from the old family wood shed to the five-figure check he now draws.

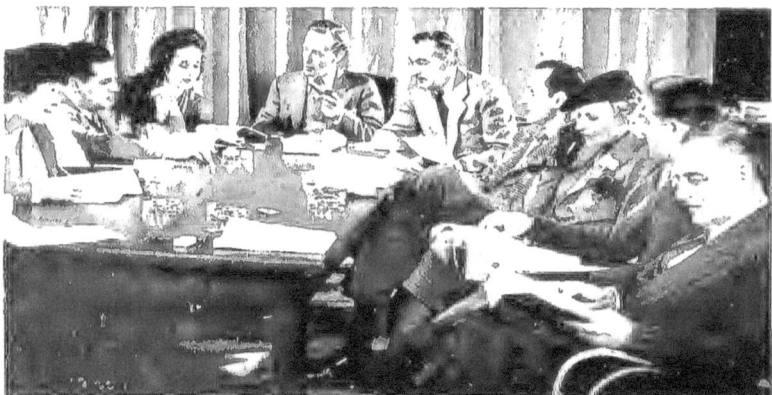

Here's the first rehearsal of lines of *Romeo and Juliet*. Assembled around a table at M-G-M are, from the left: Edna Mae Oliver, Director George Cukor, Norma Shearer (Juliet), Leslie Howard (Romeo), John Barrymore, Basil Rathbone, Mrs. Violet Kemble Cooper, William Henry and Henry Kolker. It's a big moment for them all!

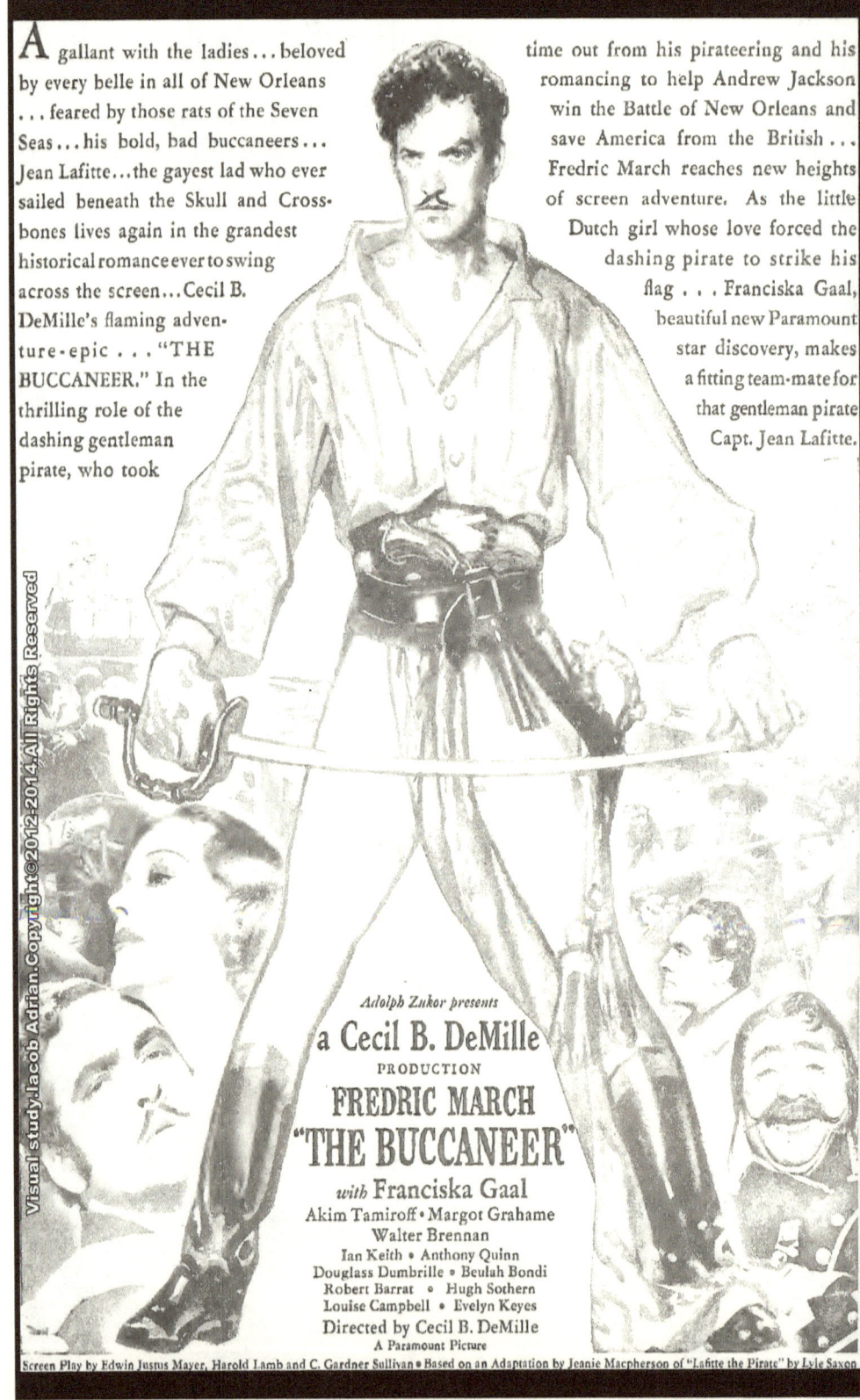

How a Star Learned to Say: "Ooooops, Sorry!"

Above, Fredric March having some difficulty saying "Ooooops, sorry!" during a scene with Virginia Bruce in *There Goes My Heart*. His next picture is *Trade Winds* with Joan Bennett playing opposite

It took a good many hard knocks to shape Fredric March's gay, gallant philosophy and you may learn some unsuspected things about the star by reading this story

By JESSIE HENDERSON

■ With all the ingenuity and desperation of a cinema journalist, Fredric March ("Bill Spencer") was trying to interview Virginia Bruce ("Joan Butterfield") aboard the Butterfield yacht at Quarantine. The chance of a lifetime! If he could coax a few words from the tempestuous heiress, he'd not only make the front page but get in good again with the demon city editor. It meant his rep. His job.

But—one well placed shove, and Fredric March was over the rail and into the sea, his hair plastered wetly to his brow, his natty suit swooshing as he began to swim. "Go away!" screamed the heiress, "you annoy me!"

"Ooooops! Sorry!" March answered out of the briny deep.

The retort brought surprised laughter from

How a Star Learned to Say: "Ooooops, Sorry"

the cast of *There Goes My Heart*, Fredric's new Hal Roach picture, for the words were not in the script. Yet they were typically Fredric March. Those words, or the mood behind them, are characteristic of March whenever a real crisis arises in his existence or his career. To him the exclamation has come to mean the summing-up of his philosophy of life. More, this jaunty lament over bad luck has often in March's experience been the prelude to luck far better than he had dreamed. Even in the picture, when the newspaperman adopts an "Oops" attitude toward the yacht incident, he wins not only the interview but also the heiress.

The March philosophy, a subject on which Fredric never talked before, has occasionally startled into delighted laughter a bigger audience than that which saw the actor tossed off the yacht. Once it convulsed New York.

On the day after Fredric's stage play, *Yr. Obedient Husband,* closed on Broadway last season (for various reasons it flopped with a dull clunk! within one week), March and his associates ran an ad in the paper. Never has there been an ad to top it, an ad so regretful and gay.

It was a reprint of a sketch from The New Yorker, showing two trapeze performers in mid air. One, whose heels are securely hooked over a bar, has failed to catch the hands of his fellow performer, who consequently is hurtling downward. The one on the bar says politely: "Ooops! Sorry!"

March had missed. He knew it. He *was* sorry—yet he was not in despair. Matter of fact, he means to go back to Broadway some time and try it again, but that's another story.

It wasn't easily, but by a devious and painful route, that March arrived at the philosophic attitude which today enables him to say, "Oooops!" instead of other assorted words when things go wrong. His father and the Orientals were the early influence.

"'Everything works out for the best,' how often my Dad told me that," March said when, in dry clothes again, he was back in his trailer-dressing room on the Hal Roach lot. His keen, dark face grew thoughtful, his brown eyes went quizzical, at this remembrance of his boyhood. "And if you have the patience to wait, those words are likely to come true. Things work around, fall into place. There's a bit of Oriental wisdom, also—Confucius, isn't it?—that's helped me over many a hard spot: 'This, too, will pass.'

"I've discovered a peculiar thing about that saying. Not only does 'this, too' pass (whatever rotten luck it may be), but generally you find yourself the better off for having gone through it. If it's grief, you come out with greater sympathy for the grief of others. If it's poverty, you come to appreciate money when you have it. Keep that ancient four-word promise in mind and nothing can get you really down."

The first time Fredric said, "Oooops!" to a sharp emergency, was in his home town of Racine, Wisconsin. Fredric came home from high school one noon, swinging his senior Latin and Algebra books on a strap, to find his father, white-faced, in the hall. "The bank has failed," his father said.

He didn't need to say more. It meant, as Fredric knew, that his father's money—he

MAN!
What a Man is FATHER!

Sis doesn't chase the fellows... Father does!

Brother has an eye for girls... Father has his eye on brother!

WARNER BROS. delightfully present the most affable, laffable family that ever stepped out of America's screens . . . into America's heart!

FREDRIC
MARCH
MARTHA
SCOTT

In the big new hit based on the year's most celebrated best-seller!

But to Mother— Father's just her biggest baby! ...He always has one foot in heaven —and the other in hot water!

"ONE FOOT IN HEAVEN"

With BEULAH BONDI · GENE LOCKHART
ELISABETH FRASER · HARRY DAVENPORT
LAURA HOPE CREWS · GRANT MITCHELL
Directed by IRVING RAPPER

Screen Play by Casey Robinson • From the Book by Hartzell Spence
Music by Max Steiner • A Warner Bros.-First National Picture

A BEDTIME STORY EVERY WOMAN WANTS TO BE TOLD

WITH **GESTURES!**

...GESTURES that tell a love story too thrilling for words... from the first kiss... to the last embrace ...with time out for laughs that are the year's loudest!

Fredric **MARCH** TELLS Loretta **YOUNG**

A Bedtime Story

"You men will tell this one to all the girls!"

with ROBERT BENCHLEY ALLYN JOSLYN · EVE ARDEN · HELEN WESTLEY

Directed by ALEXANDER HALL · A COLUMBIA PICTURE

My Life Story - OR IS IT?

Fredric March's own intimate, inside story of his hectic career—perhaps!

As told for the first time to CROMWELL MacKECHNIE

I WAS paddled to life back in '98 in Racine, Wisconsin, and was the last child born to my parents, which, in itself, was enough to make my two brothers and my sister older than me. An odd family, what?

Consequently I was the youngest child and very often left to play alone. This fraternal neglect gave me an early training as a mime, for, when I wanted to play "cowboys and Indians," I not only had to be the "puncher," but the redskin as well.

With this broad training, it is not astonishing that I should have been early recognized as an actor. Going back into my memory—by train this time; last time I went back on a bicycle—I can remember my mother as the first to comment on my thespian ability.

"Fred," she scolded, as she led me by the ear from a room full of shocked guests, "Fred, I simply can't understand what makes you *act* that way!" A neat compliment.

At another time—I was about ten, I think—I imitated an old gentleman, who looked and walked like Santa Claus, with such success that the neighbors were thrown into gales of laughter, by which the little girl next door was blown far out into Lake Superior, never to be seen or heard of again.

HOWEVER, these little successes failed to turn my head, so, instead of running away with the circus, as the neighbors hoped I would, I did the adventurous thing and went to school.

From grammar school, I went directly to the University of Wisconsin—pausing only for four years at the Racine High School as a propitiatory gesture to the University Dean of Admissions.

My brother, Jack, had been a student at the University before me, and he wrote his fraternity a letter warning them against his little brother, Freddie. But the rushing committee misunderstood him, and I was suddenly initiated into Alpha Delta Phi. Of course, once they had me, they had to do something toward making me a credit

My Life Story

to the Alpha Delts.

"What can you do?" asked the house president in a tone that warned me that, at least, I'd better be able to play the saxophone.

"I . . . I can act," I managed to gulp.

"Good. Sign up for freshman track."

"B-but I said act."

"Oh, act. Well, join the dramatic club. Report for track, too. And you may as well compete for the football managership."

That gave me practically nothing to do until my Junior year when the United States entered the war, and I decided to enlist.

"What would you like to be?" the recruiting officer bawled at me.

"A captain," I confessed.

"No, no. What branch of the service do you want to join?"

"The navy."

"We have a sailor."

"Then I'll take the infantry."

"Too late—someone just took the infantry. I'll put you in the field artillery."

"But I don't want to be in the field

artillery," I managed to gulp. "You should have spoken sooner. You're already in it."

H E was right, as it turned out. But the outfit I trained with never got to France. We *were* going but, just before we got the horses packed, somebody in Washington heard about it. "Hurry up and sign the armistice," word went out. "March is about to get a trip to Europe."

That did the trick, and before you could bat an eye—or even a three-bagger—they had called the whole thing off.

My fraternity brothers must have noticed my disappointment, because, when I got back to the university, they made things up by electing me president of the senior class, football manager, and an Iron Cross man. They even fixed it for me to be graduated, Class of '20.

Diploma-ed, I went to New York City to work as a student clerk in the National City Bank, but, after I'd been there awhile, I began to look around me.

"Where will this banking get you?" I asked myself, one day. "Look at Morgan. Who ever heard of him? No," I continued, still talking to myself as if I were an old hermit, or something, "No, Fredric, banking is not for you. Turn to your first love. Be an actor!"

N EED I tell you of my early struggles? Need I tell you of the Brooklyn boarding house, and the months spent posing for commercial advertising? It was a happy day for me when the late David Belasco gave me a part in "Debureau."

From then on I worked pretty steadily. Then, back in '26, I went to Elitche's Gardens, in Denver, to play leads in summer stock. I arrived in Denver in a blue funk, and went directly to the theater to rehearse. There, I met Florence Eldridge and immediately traded in the blue funk for a red express wagon. Here, I knew, was my soul mate; here was Beauty; here was Love; hear no evil; speak no. . . . But that's a different story.

The March motto in marriage has ever been, "Papa *uber alles*," which means, "Remember the two bears." So our marriage has been always serene. Only once has Florence glowered. That was when I was rehearsing for the part of *Tony Cavendish* in the Los Angeles production of "The Royal Family," and trying to pattern the character after John Barrymore, whom it is alleged to have been written around. I strove to dress, think and be Barrymore—until Florence very deftly pointed out that it was I, and not John, that she had married, and, for heaven's sake, desist. She had me there.

B UT there were almost two years between the day we were married and "The Royal Fandango," or whatever I said that play was. Part of those two years was spent on a tour of one-night stands Florence and I made for the Theatre Guild. When that was over, we decided to do something different.

"Let's do something different," I suggested.

"What, for instance?"

"Go touring."

"That *would* be different," Florence admitted.

So we went auto-touring into New Mexico and Arizona. Some people claim to have sighted us in California, but I don't know—you can see pretty far on a clear day in the Old Southwest.

Eventually we creaked back to Denver where I'd been engaged for another season at Elitche's, but we hadn't been there long when I got a wire from Los Angeles.

"They want you in Los Angeles," said Florence when she'd opened it for me.

"Let them extradite," I defended.

"It's not the police who want you, darling. A producer wants you for the lead in 'The Royal Family.'"

"And I'd have to play the part of an actor?"

"Yes."

"I won't do it. It's bad enough to have to *be* an actor, without having to *act* an actor, too. Besides, I want to be a sailor."

"Why haven't I heard about this sailor business before?" Florence quizzed me, using a hand-painted quizzer she had just tacked together.

"Because I just decided. Everyone has a suppressed desire, and that's mine—I picked it out of the fifty prize winner for 1928."

B UT I did come to Los Angeles. Shortly after, "The Royal Family" opened. Opening night, I had a visitor to my dressing room after the performance.

"Mr. Barrymore is here to see you, Mr. March," the call boy tossed off.

I looked around for something to toss off, myself. Not finding anything, I seized my trousers and headed for the window. "See if you can stall him off while I make my getaway," I implored.

"Aw, he ain't sore," the boy soothed. "He thinks you imitated him pretty swell."

Mr. Barrymore was very nice to me. So were a lot of other people, mostly producers and agents. One day a man I didn't know just sort of grew up in my dressing room.

"I'm Al Rosen," he said. "I'm an artists' representative."

"I don't want any etchings," I said with great sales resistance. "I have an etching."

"It's not that kind of artists I represent," Al assured me. "I'm an agent. I want to be your manager."

So, all of a sudden, I had a manager who wanted to put me in the talkies which were then in their infancy and had to be changed at least three times a day. Al came in to see me, the day after I'd taken my first screen test.

"I've signed you for a role," he greeted.

"Good," I came right back at him. "Now, see if you can sign me for some coffee, and I'll invite you to breakfast."

But, instead of coffee, he signed me with Paramount on a long-term contract—and there you are!

And here I am. Aren't we all? Anyhow, that, my son, is practically my life story.

RALPH BELLAMY tells on FREDRIC MARCH

Sometimes your best friend *does* tell, and Ralph says Fredric March is an incurable clown

By RALPH BELLAMY

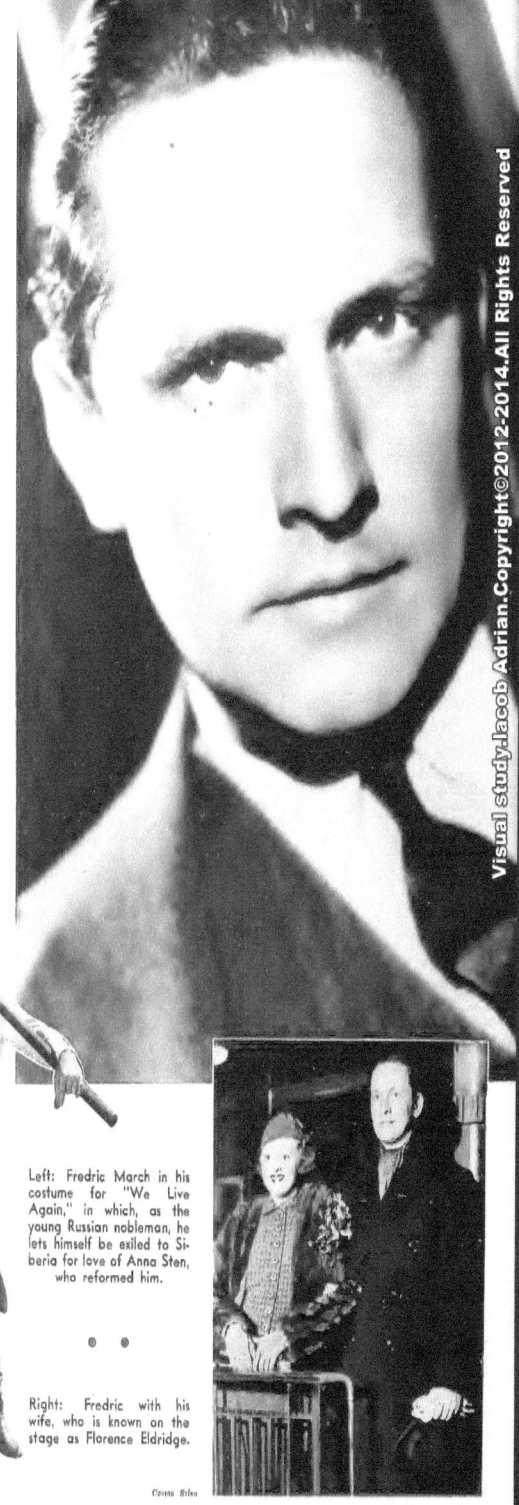

Editor's Note: Few persons could be so well qualified to present an intimate picture of Fredric March as Ralph Bellamy. The two families are Hollywood's most popular social foursomes, and their close association enables Ralph Bellamy to reveal the unknown Freddie March whom we should all like to know.

SERIOUS as he appears on the screen, the Freddie March I know is a born comedian. Sometimes I suspect he is possessed of an imp, for the way he gets into mischief is little short of diabolical.

But try to put your finger on his humor, and it eludes you. He makes fun on the spur of the moment, and will seize upon an opportunity to pun, with the most excruciating results. At certain times he will go on a veritable punning spree that is positively fiendish if not devastating.

The practical joke is not for Freddie. That style of humor is premeditated, and Freddie March never bothers to arrange a laugh. His penchant for funmaking crops out as soon as he gets off the set. When the director sees a wicked gleam coming into Freddie's snapping eyes, he may as well sit back and wait until March gets the mirth out of his system, for his is the kind of puckish, whimsical humor that will bubble over when you least expect it.

One night the four of us—my wife Catherine, Florence Eldridge, Freddie and myself—decided to attend a Shakespeare play. Freddie and I had both trod the boards in the Bard's dramas, and we hankered to hear the sonorous lines again.

Unfortunately the performance was so poor as to send us all into utter boredom. And that is one thing that Freddie can't endure. He and I began to fidget and squirm, and finally began a low but heated argument over nothing at all.

Two very fat female devotees of the theater kept turning around and glaring balefully at us, but Freddie was in no mood for behaving himself when Shakespeare was being done to death behind the footlights.

This went on for some time, with the ladies in front shushing and glaring back alternately. Finally, during an important hush on the stage, the fat lady in front of Freddie sneezed.

Freddie leaned forward, outraged and dignified, and tapped her on the shoulder.

"Quiet, please!" he said in a tone of great annoyance.

The irrepressible Freddie used to be a

Left: Fredric March in his costume for "We Live Again," in which, as the young Russian nobleman, he lets himself be exiled to Siberia for love of Anna Sten, who reformed him.

Right: Fredric with his wife, who is known on the stage as Florence Eldridge.

perfect pest at bridge parties. He would drive us frantic with *sotto voce* kibitzing, and look hurt if we protested. In pure self-defense we determined that he would either have to learn to play or be locked up in the cellar.

Catherine, Florence and I cornered him one day down at their Laguna Beach home, and crowded all "ten easy lessons on bridge" down his throat at one sitting. It was our only hope of bringing peace to our innocent little diversion.

But we all had to listen first to Freddie's protest that bridge was the cause of quarrels, bickerings, divorces and (hoarse whisper) even murder! We must swear a solemn oath never to say a cross word across the bridge table.

We sat down to our first game, dealt the cards, and played out the hand. As the last trick was taken in, Freddie levelled his finger at Florence and excoriated her with: "Why did you make such a terrible lead? You could have set them by leading back my heart! And if you must play bridge, play it well or don't play at all!"

For a few horrified minutes none of us realized that it was another of Freddie's ribbings.

Actually, I have yet to overhear a cross word between the Marches. They are completely devoted, enjoy each other's company thoroughly, and truly know the secret of enjoying a happy marriage. Possibly this is due in a measure to the fact that both have such a grand sense of humor.

Freddie March is generous to the point of making it his only vice. His tender heart marks him out as a softie for the cagers and petty grafters one encounters in picture business.

There is one actor here, for example, whom Freddie has supported for years. Freddie doesn't think any one knows it, but I have observed Freddie going to great lengths to get this old fellow a day's work in pictures, so that the actor can preserve his illusion that he still is capable of earning a living. At regular intervals Freddie delivers a check to him—often the old boy collects it in person for the pleasure of a chat with his benefactor.

He is extremely generous in his gifts to Florence, yet so exceedingly sensitive is he that he will studiously avoid any opportunity for her to thank him before others. I remember one Christmas when, after she had unwrapped so many gifts that it would seem Freddie had exhausted all his resources, he assumed an air of nonchalance and drew out a crumpled wad of paper from his pocket.

"Oh, yes, here's something I forgot," he murmured, and tossed her the packet.

It was a gorgeous dinner ring, but when Florence turned to thank him, he had slipped away.

He takes his screen work very seriously. It is exceedingly important to him and to his wife also, for Florence—herself a noted actress—gives his career precedence.

The fact that his roles usually call for sober and intent characterizations is sufficient reason for the public to obtain a different picture of the March on the screen and the Freddie of private life. Even so, one can detect that undercurrent of mischievous humor that makes his pictures so unforgettable.

He has a fine dignity of bearing, and is practical and level-headed in his affairs, but that irrepressible humor will come popping and bounding forth at the most unexpected moments.

I have seen celebrities gather about him as if they were magnetized. His keen wit and his attractive personality naturally draw people to him.

But let there be one of those pompous, conceited, puffed-up fellows enter the group, and beware!

Freddie has few antipathies, and the egomaniac is probably all of them.

He deals with them in his own devastatingly ingenious manner, leading the fellow on to boastful heights, masking his intent with a very serious face while the rest of us struggle to hide our growing amusement. Then, with one bold thrust, Freddie will completely deflate the egotist. He does it so cleverly that the fellow may not even be aware of what has happened to him. As a pin pricker of pomposities, Freddie knows no master.

He has a tremendous supply of nervous energy and is constantly on the go. During a bridge game I have observed him trying to sit still, and failing, he will get up and empty ash trays or stride off after cigarettes, even while playing a hand.

It seems Ralph does a little clowning, too. He and Freddie put on this horrible imitation of Clark and McCullough at a Hollywood costume party.

This nervous restlessness makes it impossible for him to sit back and let a chauffeur drive the car. He must always take the wheel himself. He does everything well, and is a fine driver, but the way he goes around corners and scoots through traffic will make your hair rise.

When we are going out together, Catherine and Florence will often take the back seat where they can talk. But after a few blocks most of the remarks are directed at Freddie's breath-taking style of motoring. If we are late for a social engagement, Freddie considers this sufficient excuse to show us all what real

At the left, Ralph, and at the right, Ralph and Freddie playing badminton. Freddie, you'll notice, still flaunts his "Wimpole Street" whiskers.

Ralph Bellamy Tells on Fred March

speed is like, and the squeals of anguish emanating from the back seat on such occasions must startle the pedestrians out of our way, for we bear a charmed set of lives on those rides.

Can you imagine Freddie March playing the role of father in real life? I couldn't either—at first.

When Florence first broached the idea of adopting a baby, Freddie snorted and scoffed. He gave side-splitting imitations of himself walking the floor with a baby, and presented profound arguments to prove the utter ridiculousness of the whole scheme. Adopt a baby! Absolutely not!

So they compromised and adopted a baby.

The first thing we knew, Freddie had gone completely berserk over that child. He prances and romps with her until little Penelope March gurgles with sheer joy. The Laguna Beach home—always their favorite retreat—was originally a rather small affair. But now look at it! Proud Papa March, having taken up a career as a father, could be content with no half-way measures.

There had to be a nursery. It is almost as big as a Hollywood drawing room. Then quarters for the nurse, and a special kitchen. He even had a dumbwaiter built from the main kitchen to the nursery, so that if her majesty Queen Penelope should desire a midnight snack from the icebox, the nurse had only to press a button.

He fairly haunts the nursery, and prowls about to see that all is shipshape while Penelope takes her beauty rest.

The other day he proudly surveyed the big nursery, and remarked:

"With so much room, don't you think we ought to adopt a couple more babies?"

Florence, being a most dutiful wife, smiled and yielded not to the temptation to say—"see, I told you so!" Freddie believes in doing a thing thoroughly, once begun!

THE Laguna home is an ideal retreat for them. It stands on a high cliff some three or four miles south of the town. Back of the house is a veritable wilderness of hills and canyons, and our favorite diversion is to go hiking there. One day we four set out to explore strange territories.

Freddie and I had climbed through a fence and were striding along some distance ahead of the girls, when we looked up to behold ten big, belligerent bulls lined up in our path. Freddie and I came to an abrupt halt. Then Freddie asked, with a lift of his brows: "Do you, ah, think they like people?"

One of the bulls stepped toward us. "They do not like people." Freddie observed quickly. We marched back to the girls, who silently joined the solemn procession back to the fence, through it, and then, from a safe distance, we looked back. The bulls had not moved.

No bulls frequent the beach at Laguna, however—unless we count some of Freddie's verbal ones. He and Florence take the baby down the steps and spend hours on the sand. But lying still is not for Freddie—he brings along a medicine ball and finds someone to play catch.

His house is full of games of all sorts. designed to entertain those who abhor the simple delights of sitting and thumb twiddling. No matter what the game, Freddie usually can win it.

Freddie is a born entertainer and host. The March's dinners, usually for six or eight, are social highspots.

Freddie has very few dislikes—aside from bulls and egotists. He tours through life in high gear, enjoying every minute of the ride. But he has one very definite dislike. A most definite one—toward physical labor. He will expend a prodigious amount of energy to avoid downright work.

I discovered this secret grudge for labor one time when I proposed that we make a badminton court. By leveling a slope near the beach house we would have a splendid place for the game of shuttlecock, but Freddie eyed the spot with disfavor. We searched diligently for two days and finally came back to the original site.

"All we have to do is shovel away that dirt," I pointed out. "Come on, here's a shovel. I'll use the pick."

Freddie made several passes with the shovel, then recalled an urgent errand in town. After that he remembered that he must call the studio. I made up my mind to see the thing through, and it became a silent, bitter struggle between two determined souls—I to make Freddie work, he to get out of it. Finally he capitulated, and when he made up his mind to it the court was finished in short order.

HE has a splendid physique and despite the nervous restlessness of his make-up, is robust and healthy.

To a large measure the credit belongs to Florence. No late hours when a picture is in production; good food thoughtfully selected for dietetic values; cheerful, happy environment at home.

Sometimes Florence may become over-enthusiastic in diet regulations, as I have cause to know. There was one dietary siege when we must use celery salt and no pepper, eat gluten bread, and use saccharine instead of sugar in our Sanka coffee. As an added touch we must drink flax seed tea before retiring. I strongly suspect that Freddie was as relieved as I was when this spell passed. But it keeps him healthy.

He is a most tractable husband and dutifully eats what is good for him. After regarding my own shortcomings and those of others, I would nominate him a really remarkable husband.

Freddie is very devoted to his family, which consists of his father, two brothers and a married sister. They correspond regularly and visit back and forth. He takes his fraternal affiliations with the most serious regard, and is proud of his alma mater, the University of Wisconsin.

The success he enjoys in pictures was won by years of hard work, and though he may use all that clever wit and ingenuity to avoid labor, when it comes to picture business he does not spare himself. It is odd to remember that he had to be coerced into leaving a bank teller's job to start his theatrical career, for, more than any man I know, he loves the drama.

I have, I hope, given you some inkling of the splendid fellow that is Freddie March. It is difficult to catch that engaging personality with words. Perhaps I could express it all quite simply, in just one short sentence.

No one could ask for a finer friend than Freddie March.

MEN OF STEEL

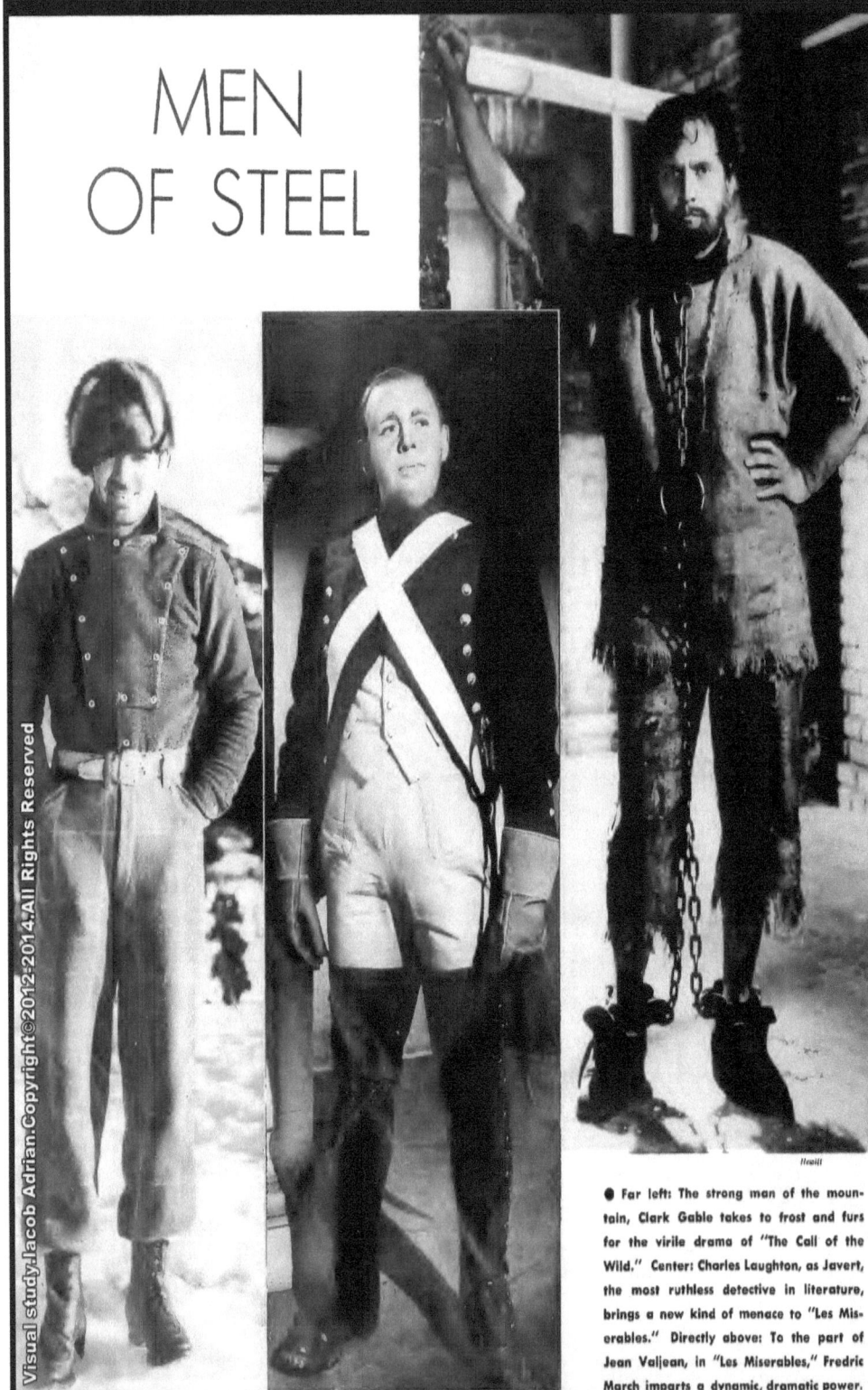

● Far left: The strong man of the mountain, Clark Gable takes to frost and furs for the virile drama of "The Call of the Wild." Center: Charles Laughton, as Javert, the most ruthless detective in literature, brings a new kind of menace to "Les Miserables." Directly above: To the part of Jean Valjean, in "Les Miserables," Fredric March imparts a dynamic, dramatic power.

HOLLYWOOD is Dangerous to YOUTH

says GENE RAYMOND

At last an honest, intensely sincere answer to this important question, from one of the younger stars himself

By JACK JAMISON
Exclusive to New Movie

HERE'S a criticism you've heard often enough from welfare organizations, professional viewers-with-alarm, and women's clubs. But rarely have you heard it from a star right on the spot!

"Hollywood is dangerous for young people."

Gene Raymond is the one who says it. Not only is Gene a star, but he himself is young. This, coupled with his broad experience, plus the fact that he is successful and therefore can't be accused of sour grapes, makes what he has to say worthy of attention.

"You understand, of course"—he explains—"I am not speaking of Hollywood as a geographical place. A town is a town, and one is no worse nor better than another. What I refer to is the set of economic and psychological conditions in which you find yourself in Hollywood; of the town as an environment. The movies have become a goal for young men and girls all over the country. They flock to Hollywood. My point is that what they are liable to find there may be more harmful to them than beneficial.

"Consider the experienced young players who come to Hollywood from the New York stage, from little theaters like the Pasadena Community Theater, from stock companies, vaudeville—youngsters who've already had experience in some branch or other of the theater. Not only are they boys and girls who are truly interested in the drama (they must be, or they wouldn't be where they are) but they have already managed to survive the hard knocks of apprenticeship. They have, to some extent, demonstrated their ability. At last a studio scout spots them, they sign a contract, and they're in Hollywood. What happens?

"Right off the bat—and it's a sad blow—they learn they aren't their own bosses. According to the contract, a producer owns them body and soul. He can make them over, if he doesn't like them—dye or bleach their hair, have their teeth pulled out, their eyebrows shaved, their faces lifted; teach them to

The glimpse of Fredric March in a "Les Miserables" mob scene, in circle, and the photos below, give a hint of the terrific tension under which pictures are made. It is this tension, Gene says, which wrecks nerves and health.

Joan Blondell and William Gargan making "Traveling Saleslady" . . . Charles Laughton in "Les Miserables" . . . George Arliss rests from "Richelieu."

Hollywood Is Dangerous to Youth

walk and talk in a wholly different way. He puts them into pictures he wants them to be in, not the ones they want to be in. Maybe these are pictures they're not even suited for. Maybe they're not good pictures, not pictures of a young actor, with achievement behind him, can really feel proud of.

"Immediately, in other words, the young newcomer to Hollywood gets two shocks which can ruin him for life as an artist. He finds that the producer didn't want his true personality at all, and he is shoved into pictures which neither suit his talents nor enable him to maintain his integrity and self-respect as a performer. Those two disillusionments alone can ruin a whole career. You have to have super mental strength to overcome them.

"It's only because he has strength of this nature that Clark Gable has managed to keep his head, the way he has. When Clark came to Hollywood he wanted to do light comedy. The producers turned him into a tough guy. Those tough characterizations—not Clark's real personality at all—made him a star, so the producers forced him to go on with them, against his will. His being cast for 'It Happened One Night' was pure accident. It took an accident, after four years, to show them that Clark himself knew what he was talking about! How many other men could have lasted out these four years?

"Now, suppose the young man or woman we're talking about makes a terrific success. Then what happens?

"There's that nice, fat salary check every week. Personally, he knows that first picture wasn't so good. It doesn't come within a thousand miles of living up to the ideals he has set for himself. It's just box-office hokum. He hopes the second picture will be better, will have some artistic truth and beauty in it. It isn't. Neither is the third. Neither is the fourth.

"A young actor with pride in his profession, and some spunk, will fight. He goes to the producer and says, 'Give me a chance to act. Give me a picture I can be proud of!'

"The producer pats him on the back and says, 'Now, now, everything will be all right.'

But the fifth picture is just some more hokum. Box-office is box-office. The youngster is a success, and, because he's a success, he's trapped. He has only two choices. He can either go on, hoping that things will change, or he can quit, walk out on his contract, and go back on the stage. But, every week, that nice, fat salary check is rolling in! It's more money than he ever saw before; more than he may ever see again. The little black devils whisper in his ear, 'Get the money while the getting's good.' How many people—particularly young people—have the moral courage to turn their backs on a fine salary and go back and begin all over again? So they stay in Hollywood, turning in box-office pictures the producers want, and one more fine young actor, capable of really fine things, has turned into a 'ham.'

"Go up to them, after two or three years of Hollywood success, and ask them why they stay, and they'll tell you, 'Oh, I like the California sunshine.' Sure. They've got a car, and a valet, and silk pajamas. Why shouldn't they like the California sunshine? And, in ous you were already? No. They get careless in front of the camera, their second picture isn't so good, their third is worse, and then they're done.

"Socially they go crazy, too. Yesterday they were nobody. Today they're asked to dinner at the homes of famous executives, writers, and stars. When they take a trip to New York they find themselves in the homes of people whose names are in the Social Register. They see so many glasses of champagne that they forget what water tastes like, some of them. They've been living on pot-roast and cabbage all their lives, and suddenly they're having lobsters. Their heads can't stand it and neither can their stomachs or their nerves. Equilibrium is impossible for them. They were caught off balance, and they can't get back. The old-timers know that pictures demand such a terrific amount of energy that it's impossible to keep up such a pace, but the youngsters don't. They go the pace, and it wrecks them inside of two years. Sometimes inside of two months!

"And that brings me to Health. I'm a bug on health, myself, so I'm particularly interested in studying the effect Hollywood has on people from this angle, and the reports I have to give are anything but encouraging. The greater the success you make, in Hollywood, the more your health suffers. Take someone like Claudette Colbert, who is so popular that she rarely gets a week's rest between pictures, and has to read the script for one while she's finishing another. A couple of months ago she went down with pneumonia. About the same time, Miriam Hopkins was in the hospital with bronchial pneumonia. Ann Harding had to take a long trip to the Orient, ill from overwork. Clark Gable, for a while, was so sick that I wondered how he worked at all, although he never let on. I've just named a few, but go down the list and you'll be appalled how often stars go into the hospital. I've seen magnificent specimens of health turned into physical wrecks by two years of studio strain. It's the same answer in every case—nervous strain, overwork, then lessened resistance and inability to fight off the first germ that comes your way.

"My point is—if it's so tough for experienced stars, who realize what a strain picture-making is and take constant steps to safeguard their health, what is it for youngsters new to the game, who don't realize what they're up against?

"What we call morals are really mental health, and the same danger is present there. A newcomer, brought up with conventional folks, suddenly finds himself in a town, where, last year, there were more divorces than marriages. All his old moral notions go by the board, and, if he is young, he has no sense of balance with which to make up for them.

"Spiritually, mentally, morally, artistically, physically, intellectually—in almost every way, Hollywood is dangerous to anyone in the twenties. Any article like this can only be one man's opinion, but mine is an honest opinion, at least, and I give it for what it's worth. If anyone of my own age or less comes to me and asks, 'Shall I go to Hollywood?' my answer is: "The benefits you may get out of it are no match for the grave dangers you'll run."

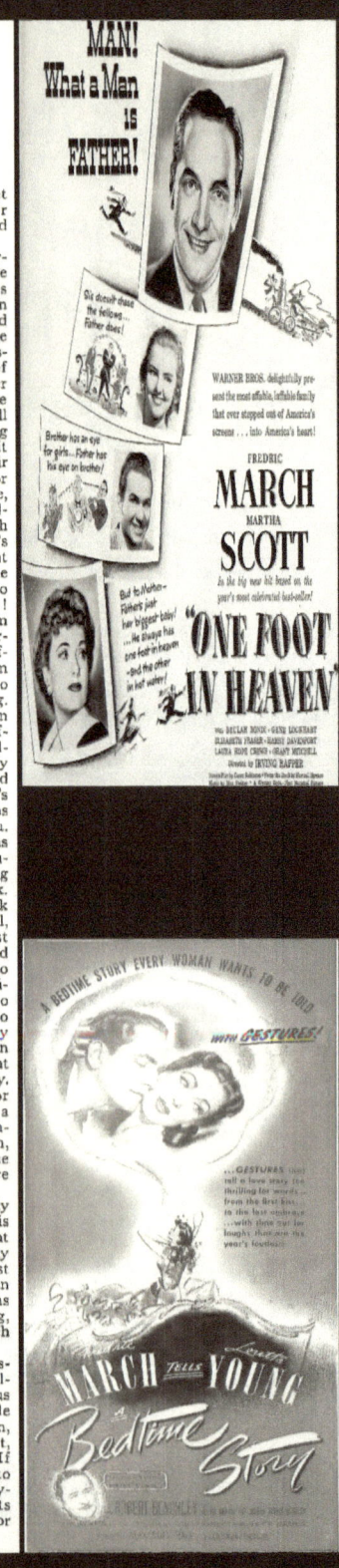

Ralph IS MY PAL

By FREDRIC MARCH

Some time ago we printed a story about Fredric March, by Ralph Bellamy. Here's where Freddie gets even

IF I were going to be isolated for six months in some spot at the end of the world and I was given the privilege of having only one male friend on this retreat, I'd choose Ralph Bellamy as the perfect companion . . . for the rich conversations, the mastery of emergencies, the sense of humor and the merciful silences he would bring to such an experiment.

On the other hand if some lofty-browed scientist could successfully throw me back to my college days and years and send me on a jaunt to Paris with a pocketful of money and a bucket of red paint I'd still pick Ralph as the ultra-streamlined ideal companion in whoopee!

For four years we have been the best of friends (our wives are friends from stage days) and we are as inseparable as studio callboards will permit. In that time I've seen Ralph the center of various and varied settings . . . discussing Russian literature with the literati . . . smashing out a victory on a tennis court . . . losing a rubber at bridge with as much sportsmanship as he won the previous one . . . delving into international politics with some visiting dignitary . . . rolling a mean pair of dice on a Caliente gambling table . . . spending hours alone on the sand at Laguna Beach . . . or rallying the craziest members to play the craziest game at a

At the left, in the small insert, there's a portrait of Freddie, and at the right is one of Ralph. Below you see Ralph answering his fan mail. As Freddie tells you in this story, he answers all of it personally.

party . . . but I have never seen him out of sympathy with the event of the moment.

His adaptability is a gift that makes it possible for him to get the greatest benefit, either intellectual or just plain pleasure, out of everything he does.

I am constantly amazed at the wide circle of friends he has. On every hand I bump into people who know Ralph and the group ranges from music reviewers to the kids at the corner gasoline stations. All children including my own are wild about him. . . . If his even disposition permits him any particular aversion it is for the man or woman who is easily bored . . . or pretends to be. Life is interesting and vivid to Ralph and his own sense of adventure and thirst for knowledge makes him impatient with people who do not get the utmost out of every available experience.

Though we have known each other only since our Hollywood days I have picked up enough of his background to realize this unquenchable zest for life must have begun in his youth. He is seven years younger than I, a mere stripling of twenty-eight, yet I find myself envying his background, the store of experience he has piled up.

He has done everything I should have liked to do. When he was a kid he ran away from home. . . . He's played in stock companies and tent shows acting one week and painting scenery the next. He's been broke and affluent . . . hungry . . . struggling in bit parts, recognized on Broadway and a success in Hollywood, but it has all been just so much adventure to him, the lean with the fat, the good with the bad.

Ralph Is My Pal

If I seem to stress this point it is only because I think it explains so much of his personality, so many of his actions. He is indeed fortunate that he is married to a girl like Catherine who shares this same outlook on life. I can't imagine two people more ideally mated. Catherine is a girl with a marvelous background. During her youth she lived in London where she met the most interesting and colorful personalities of the Continent (her mother was editor of the London Vogue) and when she married Ralph she gave up a brilliant stage career of her own . . . just as Florence did in my case. Ralph and I frequently "kid" the girls demanding to know how two such intellectual ladies happened to "take up" with a couple of mid-Western hicks like us and devote their lives to "improving our minds." Many people look on the Bellamys as allied with the "artistic, intellectual" circles of Hollywood, New York and London, completely ignoring the swell, carefree, unpremeditated pattern of their married life. With Ralph and Catherine there's never a dull moment . . . for instance:

Florence and I were expecting the Bellamys for dinner one evening when about two o'clock in the afternoon we received a wire saying they would be unable to keep the engagement as they were riding as far as Palm Springs with Mr. and Mrs. Wilbur Daniel Steele who were en route to New York by motor. The Bellamys said they'd be seeing us in a few days.

It was exactly three months before we put eyes on them again!

In Palm Springs they had decided on the spur of the moment to drive on to New York with the Steeles and they wired the servants to close the house. But that is not all. In New York they went down to see other friends off to Europe . . . and decided to sail with them at the last moment! This, mind you, beginning on a little jaunt to Palm Springs . . . "back in a few days!" Nor is this anything unusual. I understand his studio has threatened to hire a detective to accompany Ralph and Catherine whenever they decided to "see someone off," as they think nothing of hopping a boat or a train with only a couple of toothbrushes between them.

They are confirmed "spur of the momenters." Six months ago they bought a farm in Connecticut (they were just passing through) and they haven't seen it since! At the time of the purchase it was supposed to be the site of their future home. Now they're talking about building in California!

In view of Ralph's unpremeditated manner of living (at least it seems hectic to such staid old tax-payers as Florence and me) one might suspect a slightly rattlebrained element in his zest for adventure. Nothing could be further from the truth. I've never known anyone so thoroughly capable of handling an emergency . . . maybe because he's had so much experience in living them!

The day of the disastrous Southern California earthquake, Ralph and I were working in Hollywood at our respective studios . . . and Florence and Catherine were at our Laguna Beach home 70 miles away. No sooner was that dreadful jar over, or the worst of it, when I received a call from Ralph.

"We've got to get going," he yelled into the phone, "I've just had word that the worst damage was at Long Beach . . . buildings are completely demolished . . . fire is liable to break out at any minute . . . !" Laguna is only a short distance from Long Beach, scene of the greatest disaster, and we were beside ourselves with worry.

Five minutes later Ralph picked me up and we were on our way. My only thought was to get to Florence and little Penelope . . . every other detail had left my mind. It was Ralph who, in his own deep anxiety, had remembered to get a police pass that would get us through the lines of the barricaded district! Without it it would have been utterly impossible to get through. When we arrived we found the girls calmly cooking dinner and thoroughly surprised to find us on the scene. We were so relieved we had three highballs then and there . . . !

I have always believed a man gets to know a great deal about another man by the way he handles alcohol. Some of the "best guys" I have ever known when they aren't drinking do a right-about-face and become quarrelsome, argumentative and quite impossible when they get in the same room with a bottle of brandy. With Ralph it's this way . . . he doesn't drink much or often. But when he does it makes not the slightest difference in his appearance or his manner. He drinks as he does everything else . . . like a gentleman!

Though he loves discussion on all subjects from religion to politics he refuses to argue and is the first tactfully to "sign off" any conversation that is reaching the heated stage. He loathes rows and will do anything to avoid them . . . or to steer others out of the mire of argument. I have seen him sit and swallow ideas which I knew were foreign to his private beliefs without any sign of disagreement. When I have questioned him about it later he has said: "But he wasn't expounding ideas . . . only prejudices."

This innate tactfulness has earned him the reputation of being extremely easy to get along with . . . and a few misguided souls may have the idea it would be easy to take advantage of him. On the contrary, it is impossible to fool him. His knack of seeing through people and ideas is uncanny. He might sit and listen carefully to the outlining of some "gold brick" scheme merely because the tactics might amuse him . . . but he would not be fooled for a minute. He might deliberately "draw out" the wise guy and let him think he had made a sale but when it was all over the spellbinder would be exactly nowhere. It is impossible to talk him into anything. He resents high pressure salesmanship in everything from politics to religion.

To his work in Hollywood he brings the same balance and sanity so apparent in every other important thing in his life. He is wholly untormented by Hollywood . . . by professional jealousies . . . by worries over billing or whether some other player gets a portable dressing-room on the set and he has to walk a half-mile to his. His only interest is in his performance and he feels that if his work is good he needn't bother getting temperamental about things that never show on the screen. He thinks about his work a great deal . . . and talks about it very little.

I have often wondered what would happen to many Hollywood actors if movieville should suddenly blow up in smoke . . . or if they legislated against it or something. The business is overrun with players who eat, sleep and breathe Hollywood. They can't talk or think anything else.

But Ralph is not one of them!

His life is filled "with a number of things" . . . !

I am proud to call him my friend!

BRIGHT COLLEGE YEARS

Freddy Bickel, Now Known to Film Fame as Fredric March, Distinguished Himself at the University of Wisconsin

BY J. GUNNAR BACK
Magazine Editor of The Wisconsin Daily Cardinal

IT is Friday night, April 2, 1920, in Madison, Wisconsin. The street entrance to the old Fuller Opera House, now a talkie palace in keeping with the times, is blazing with lights just as it had blazed several weeks before to announce Otis Skinner and his Madison performance of "Pietro," exactly as it had been resplendent in March of that same year for two other footlight favorites, Mitzi, "the madcap star," in "Head Over Heels," and George Arliss in "Jacques Duval," to say nothing of the year before when those same lights had heralded Madison's last opportunity to see Julian Eltinge before he embarked on a five-year world tour.

It was a common thing for the Fuller Opera House lights to glitter nightly during the opening years of the last decade. But this evening the walls of the historic show-house were to hear no Kern hits, no "Maytime" melodies, no "Chocolate Soldier" lyrics as they had during the year just passed. It was the opening night of the University of Wisconsin week-end, two-a-day Union Vodvil stand. "Ten Big Acts of Wisconsin's Best Varsity Dancing and Singing," painted across the theater lobby, screamed the news to fraternity and sorority couples as they stepped, clad in evening dress, out of the dark, almost spring-like April night into the glare of the electric lights.

The history seeking eye glances down that evening's program, past such promised extravaganzas as the Alpha Chi Omega sorority girls in a singing scenic, "Birds of Paradise," until it stops at this announcement, ninth on the bill: "The Sunshiners in Unsuppressed Desires," featuring Freddy Bickel and Charles "Chuck" Carpenter. An air of expectancy was awaiting that act, for *The Daily Cardinal*, student newspaper, a few days before had advance press agented: "There is sure to be a small riot when Fred Bickel and 'Chuck' Carpenter come on with their little play. They have been headliners in three other Union Vodvils. This is the last appearance of these artists."

THE next morning the Amateur Critic (for so *The Cardinal* dramatic reviewer signed himself) had this to say of that ninth number: "The third place silver cup was awarded by the committee to Freddy Bickel and 'Chuck' Carpenter by virtue of their talents as entertainers. Their line of patter was a happy combination of wit and satire on preceding acts. Their songs were good and their stage manner more pleasing than any of the other performers. They just shoved the piano in and began their rapid chatter. Because these two young men are genuine entertainers, because they try to please, because they are both Iron Cross men by virtue of other abilities than acting, they deserve every bit of praise and they got it last night. We regret that they are closing three successful years of stellar ability on the Wisconsin stage."

Today Freddy Bickel of that college toe-and-tune team is known as Fredric March, familiar to every University of Wisconsin movie-goer as a one-time senior class president, a former Iron Cross and White Spades honor society man who made good, whose contribution to the talking screen is as meritoriously outstanding as it was to Union Vodvil during his post-war days on the Badger campus. No, when March comes to town, local theater advertising writers ply an inspired copy pencil and the show always clicks with the collegians.

With Freddy Bickel, whose life, filled with promises, stretched before him, the scene again quickly changes. Seven years later and the Fuller Opera House has turned chiefly to pictures. It is the night of December 17, 1927, and the event is a flesh-and-blood drama. Freddy Bickel is back in Madison, sitting in a dressing-room in the old Fuller, perhaps the same room which he occupied as a collegian almost a decade before. This time, however, there is no bustling about backstage of amateur make-up artists, no non-professional flutter of sorority girls "going on" for the first time. Freddy Bickel has already become Fredric March. With a group of veteran

An unpublished picture of Freddy McIntyre Bickel and Chuck Carpenter (at the piano) in their college vaudeville turn called "The Gloom Pickers." Bickel is now known to the screen as Fredric March. Bickel and Carpenter were stars of Wisconsin's famous Union Vodvil performances.

professional players, he is preparing for the call to go on stage in support of George Gaul and Florence Eldridge in the New York Theater Guild presentation of Shaw's "Arms and the Man."

PERHAPS some of the members of that troupe are waiting listlessly for the routine orchestra cue since Madison is not Broadway. But with Fredric March it is different. He waits eagerly, pleasant undergraduate memories stirring within him. Local newspapers have announced the return of Freddy Bickel to the old Fuller stage, now even deserted by the traditional nights of Union Vodvil. Professors again drive up to the front of the theater. Not this time, because it is Union Vodvil to be accepted genially for better or worse as "Wisconsin's own," but because Shaw, small talk subjects for their intellectual literary teas, is in town. The theater entrance has none of the brilliance of its Opera House days, when students stood at the stage door waiting for show girls from "Listen, Lester," and "Oh, Boy." Fewer students pass through the theater doors that night of Bickel's first return to Madison. The gaiety of tradition is no longer there to cause them to hock watches for the price of a theater ticket.

Fredric March, as he prepared to go on in "Arms and the Man," knew that he was facing a test. In that audience was the professor who had worked with him in the Edwin Booth Dramatic Club, an organization largely responsible for making the name Bickel famous in Wisconsin dramatics, the same professor who had aided in awarding the third place cup to the Bickel-Carpenter team in its farewell appearance. One or two of his classmates who had settled in Madison were there. Many more had come to the theater because they admired Shaw and were anxious to see his play well done. Others came to see an advertised Wisconsin alumnus.

The student paper the next morning was unkind. It had only this to say: "Miss Eldridge had moments in which she was splendid, engaging. Fredric March and Hortense Alden, *ESPECIALLY THE LATTER*, were good in their presentations."

But Bickel's classmates and the curiosity seekers were satisfied.

At Wisconsin Fredric March distinguished himself socially and histrionically. He was a member of the Edwin Booth Dramatic Club and of Alpha Delta Phi, and he managed the varsity football team. In those days he was planning to enter the banking world.

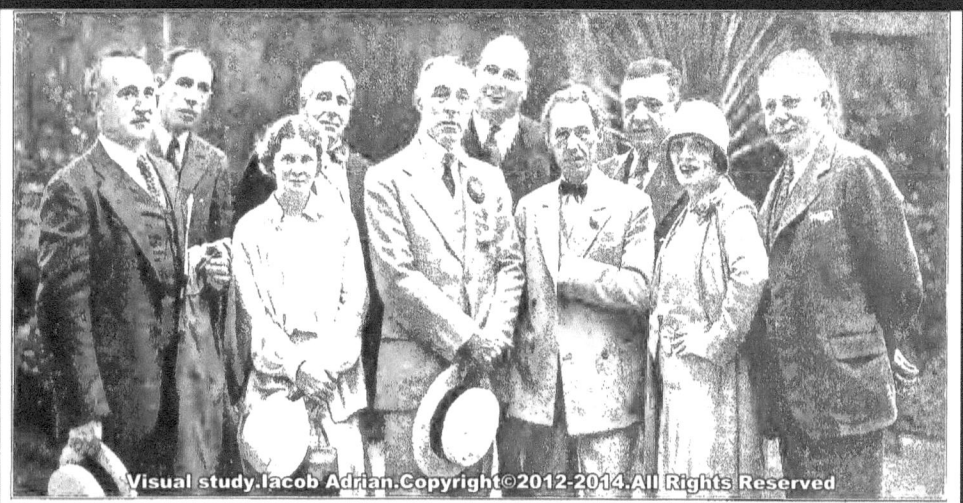

Photograph by Carl Day

When D. W. Griffith reassembled the now famous cast of "The Birth of a Nation" in order to make the new synchronized version of his classic film, most of the players responded. Death had removed several but all the others reappeared. First row, left to right: Donald Crisp, who was the General Grant; Mae Marsh, the little sister; Mr. Griffith; Henry B. Walthall, the Little Colonel; Mary Alden, the mulatto; Ralph Lewis, the elder Stoneman. Back row, Joseph Henaberry, the Abraham Lincoln; Spottiswood Aiken, Colonel Cameron; Thomas Wilson, the colored servant; Walter Long, the Gus.

Bright College Years

They went home talking about Fredric March.

Today Florence Eldridge is Mrs. March. Perhaps only a handful of people remembered "Arms and the Man" when Madison last saw Florence Eldridge do a bit in Norma Shearer's "The Divorcee." The curiosity seekers were otherwise occupied. They had learned that Nick Grinde, who had been graduated from Wisconsin five years before March, had helped adapt the scenario for "The Divorcee." Perhaps no one remembered that Laura Hope Crews, to whom movie stars of yesterday turned when the talkie menace appeared, was with the Theater Guild Company as director that week-end when March came back for the first time to his college campus.

THE flash-back opens again on another set. This time it is only two years later. "The Jazz Singer" and "The Singing Fool" have played in Madison. The city's last stock company is fighting a losing battle for patrons. Farmers are coming to town to see for themselves this new form of entertainment which squawks and grinds its sound into the recesses of the theater.

"The Dummy," with Ruth Chatterton, is playing in a newly wired downtown theater.

It was not until the next day that local newspaper critics, already grown weary with enumerating "talkie finds," cheerfully announced that they had discovered a Wisconsin man in the cast of "The Dummy."

Fredric March, with his rich, clear voice, his quiet restrained stage manner, first given roots in Union Vodvil days, had come to Madison to stay.

"The Studio Murder Mystery" and "The Wild Party," with Clara Bow, March's next pictures, added proof to the assurance that Freddy Bickel had come back to Madison to stay. College movie goers, indifferent to the histrionic tactics of La Bow, were surprised and pleased, to see the handsome, earnest actor whom Miss Bow's directors had cast opposite her. For the first time they saw a movie college professor move through the sets as if he had once endured the four-year experience of watching the classroom manner of members of the professorial ranks.

THE flash-back now turns to the early days of September, 1916, when Fredric March arrived on the war-frenzied Wisconsin campus. He was an eager, green lad of seventeen, fresh from small dramatic and forensic triumphs in the Racine, Wisconsin, High School. For two days there were long bewildering lines of students before the administrative buildings, fighting to get over the routine of registration, anxious to spend lazy afternoons in the September haze which settled early over the Wisconsin campus, situated on the lovely hill that was once the scene of the Blackhawk Indian wars. Or perhaps to ride with fraternity men in "rushing parties" around the thirty miles of wooded land that forms the circumference of Lake Mendota. At the end of those two days Freddy Bickel was enrolled in the school of commerce, ready to begin the four-year preparatory climb to banking.

Wisconsin in 1916 was not then so far removed from tradition. March wore the green "pot," rarely seen on the heads of freshmen today, fought the sophs in the annual bag rush which the freshmen won, only to be thrown into Lake Mendota at midnight for their pains. A great war of nations was gaining momentum in Europe. The more serious minded of the 7,000 students at Wisconsin were digging deeply into the sociological and economical aspects of the struggle.

Bickel, the freshman, like many others in that class of 1920, gave little heed to a conflagration which then showed few signs that it might involve the United States. He was "rushed" by the fraternity men from the Latin Quarter. There was a swirl of smokers and dinners to undergo, frantic bids to "join up with the boys" to consider. Alpha Delta Phi placed a pledge button on the Racine newcomer. In short order he was initiated into that group, taught the grip and password, and was installed, baggage and pennants, in the Alpha Delta house, a brown-stone structure which is still the home of the Wisconsin Alpha Delta brethren, snugly settled in the leafy shade of Mendota's shore, just across the court from where this is being written.

WITH the fraternity came the business of "dating," or preserving through the new brothers the cherished Alpha Delta social rating on the campus. The newcomers were brought by the older hands to the "Big Six" sorority dances to meet the hey-dey crowd

Bright College Years

of beautiful co-eds for which Wisconsin is still noted. There seems to have been no difficulty with Freddy Bickel. There were in his case no cowlicks for the brothers to tame down, no loud provincial neckties to be secretly tossed from his room into the lake. Fredric March today, if one is to judge from his portrait appearing in the Wisconsin yearbook, *The Badge*, at the close of that freshman year, has lost nothing of those handsome clear-cut features, that distinguished, quiet manner which pointed him to campus dramatics almost immediately. Or, if we are to judge from a paragraph appearing in "Skyrockets," *Daily Cardinal* humor column, written three years later on the morning after Bickel had been elected president of the senior class: "ELECTION to office has other drawbacks besides the race for nominations, etc. Freddy Bickel visited the Gamma Phi's after the election returns and was kissed by the entire chapter. Whitney, the defeated candidate, passed out when he heard this and made the announcement that if that was the reward for virtue he was glad that he knew how to roll cigarettes."

With no apology for the humor of the "Skyrockets'" writer (Nick Grinde, '15, who helped direct "The Bishop Murder Case," was one of the first "Skyrockets" writers), it might be explained that Gamma Phi is one of the intriguing "Big Six" sororities. The next semester of that senior year Freddy Bickel took a Gamma Phi to the Junior Prom.

Wisconsin veterans of Junior Proms know that that's almost like announcing the engagement.

EARLY in the fall of Bickel's first year at Wisconsin the men's amateur dramatic club opened its bid for new members. The Edwin Booth Dramatic Club ranked highly as one of the most active and influential societies on the campus. To be an Edwin Booth or a member of a literary club in that day was to gain in prestige, to move with "activities" men on the campus who were carrying its heavy intellectual and cultural burdens. Ability to act, unlike today; was recognized on a par with ability to make creditable end runs. Undoubtedly to Bickel the requirements of the Edwin Booth Dramatic Club were not too difficult, not too alarming for even a freshman's naive hesitancy. As announced in *The Cardinal* for that year, these requirements were: "a three-minute reading of some play in which at least two parts were taken and of some impromptu work in characterization."

The Racine candidate passed the test and was enrolled as a member of the Edwin Booth Club.

Evidently like all other neophytes, Freddy Bickel's dramatic lights remained hidden that first year under the bushel of collecting tickets at the sixth joint-productions night of Edwin Booth and Red Domino, girls' histrionic organization, at the Fuller Opera House, or of supervising amateur makeups before his fellow Edwin Boothians went on. Grease paint was in the blood of young collegians in those days before the talking pictures opened an easier, less creative way to indulge in the fascination of the footlights. Even Philip LaFollette, son of the late national figure, Robert M. LaFollette, who was candidate for the Presidency of the United States in 1924, left his debating and oratory interest at Wisconsin that year to take a part in the French play.

Today Philip LaFollette, March's classmate, is governor of the state of Wisconsin.

SO Freddy Bickel's gift from Edwin Booth that year was a greater urge to the footlights, his picture in the 1918 yearbook with the Booth Club, and his name, "Fred McIntyre Bickel," listed with the active thespians, all of them as obscure today as March is famous.

But he had sought other fields apart from Edwin Booth, Alpha Delta Phi, the classroom, and Gamma Phi. On the night of March 8, 1917, when the judges met in Music Hall to decide the winner of the annual gold fob medal in the freshman declamatory contest, they cast their ballots for a quiet, convincing freshman named Fred M. Bickel. He had delivered the obscure declamation: "An Invective Against Corry," in, as *The Cardinal* reported it, "a rich oratorical voice accompanied by perfect platform poise." Today Carl Sandburg and Vachel Lindsay speak in Music Hall when they come to Madison and the varsity debate teams still meet there for their annual clashes.

In the yearbook of the year 1917, above Bickel's picture as winner of the Frosh Dec, is that of Philip LaFollette as second place winner in the sophomore open oratorical contest.

Thumbing further the pages of the yearbook for 1917, the history seeker finds the name Herbert P. Stothart, another Wisconsin undergraduate, who was living with Bickel in those Badger collegiate war days. On the page devoted to the year's activities of the Haresfoot club, men's musical comedy organization which each year still travels the mid-West featuring men dressed in chorus ladies garb, is found this modest announcement: "The music for this year's hit, 'Jamaica Ginger,' was written by Herbert P. Stothart."

TODAY the whole world has seen Lawrence Tibbett's triumph, "The Rogue Song," and is humming the tunes Herbert Stothart wrote for the Metropolitan Opera star's first vehicle. As a member of the Metro-Goldwyn-Mayer song writing staff he has contributed to many other talkie productions.

For one who has seen the magic web of film fame spun only while seated somewhere in Aisle 3, flashing back on Fredric March is like reading "Alice in Wonderland" for the first time.

The Summer months slip by until it is another semester. Bickel, now a sophomore, hurls the freshman into the lake and helps bring new men into Alpha Delta Phi and Edwin Booth. The United States is on the verge of war. Germans on the campus try to forget that their native country should have won long ago. The Reserve Officers' Training Corps swells its ranks with incoming students. There is daily drilling on the lower campus. Bickel, the cadet, marches in the ranks with the rest of them.

On Saturday night, December 8, '17, Haresfoot Follies are introduced to a Wisconsin crowd in Lathrop Hall. It is the night when Wisconsin men cavort across the stage dressed as women, bearing out the Haresfoot club motto: "All our men are ladies, yet everyone's a gentleman." The sixth act is billed: "Paul Rudy and Fred Bickel with girls and boys in 'Whenever I Think of You.'" Bickel at last has made the lights, for he is billed with Paul Rudy, that never-to-be-forgotten Haresfoot female impersonator and singer who for three years toured the mid-West with the Wisconsin club, grabbing the notices from provincial as well as metropolitan critics.

Once started, the way to stage fame at Wisconsin was easy for Freddy Bickel. Five months later he was back at the Fuller Opera House, scoring in Percival Wild's "The Unseen Host," in a joint dramatic night given by the Wisconsin thespian clubs for the benefit of the Red Cross.

WHEN the yearbook came out that spring, there was Freddy Bickel's picture with the hand-picked little group of sophomore Wisconsin aces. In that picture Bickel was standing before the brownstone Alpha Delta House, dressed in semi-peg top trousers, a huge starched collar and a flowing tie, knotted large enough to throw the whole figure out of balance. Three years later he was posing in New York for Howard Chandler Christy.

A half year more passes, and Freddy Bickel is wearing the uniform of a soldier in the United States artillery forces. While the literary societies on the campus were sincerely and earnestly debating conscientious objection to bearing arms, Bickel and a bunch of Alpha Delts, members of the Wisconsin Council of Defense, had enlisted.

The stride to advancement for which Bickel had already shown such great aptitude in two years of university life, shaped a quick course for the disciple of Edwin Booth now wearing, like so many of his fellow collegians, the khaki of that first year's patriotic enthusiasm. He had doffed a cadet's insignia by enlisting in Racine on June 3rd, 1918, with the regular army forces. University drill experience gave him immediately the rank of second lieutenant, field artillery, unassigned. Army orders brought him down to Fort Sill, Oklahoma, after a few months at Fort Sheridan, Illinois, where Wisconsin's student infantrymen still train during the Summer months. Fate did not include Bickel in the ranks of those last hordes of men who were rushed to Flanders. Less than a year of sighting and directing practice cannon drill and his "bit" was over. On February 7, 1919, the war ended, he was mustered out in time for the second semester of the 1918-1919 year at Wisconsin. At least he had answered the call to the stage of great international misunder-

standing and conflict; it was not Freddy Bickel's fault that he took no shell-torn curtain calls.

The Alpha Delts were preparing to boost Freddy into the presidency of the senior class. Alpha Delta Phi already had the varsity football captain, who was none other than Bickel's stage teammate, "Chuck" Carpenter. To add a senior class president to the list would mean bigger and better newcomers into Alpha Delta Phi when the "rushing season" started again.

Bickel, late second lieutenant, U.S.A., had the year before been elected to White Spades, honorary junior activities society. He played the lead in the Junior class play. When the call for candidates for the class office was issued, Freddy Bickel was earning his "W" sweater managing the varsity football team. Iron Cross, honorary senior activities society, had just elected him a member. The name Bickel was known on the campus. Carpenter and his fraternity brothers did the rest. The football team came to the polls for Bickel; Gamma Phi Beta sorority did likewise. Freddy won the contest over his five opponents by a margin of 84 votes. *The Daily Cardinal* called it "the most spirited university election of recent years, with more votes cast than ever before." On the night of Freddy Bickel's elevation to the senior class president's chair, Tuesday, October 28, 1920, long lines waited on the streets downtown to see "Broken Blossoms," with Lillian Gish and Richard Barthelmess.

The year moved fast for the new president of the Wisconsin class of 1920. He was active in Beta Gamma Sigma, honorary commerce club, and the Wisconsin Commerce Club. He was a member of K. K. K. and Skull and Crescent. He announced long lists of committees, which like all senior committees, past and present, did nothing. He made his memorable last appearance in Union Vodvil. He attended the Junior Prom in a rented full-dress suit as even the wealthiest senior class presidents still do today. Near the close of the year, his future unexpectedly became settled. He was awarded the National City Bank scholarship. Members of the commerce school student body, whose scholastic standings were lower than Bickel's, envied him for that scholarship. The young graduate seemed more fortunate than many of his classmates; he was ready to enter the mythical world of post-undergraduate days with the prospects of rising in the banking world. He had become a protégé of Frank Vanderlip, the New York National City Bank millionaire.

"CHUCK" CARPENTER and Freddy Bickel said good-bye to each other at noon one June day after they had marched greensward with the 1920 graduates across Randall Field to receive their diplomas. Carpenter, football captain and entertainer extraordinary, like so many football captains, went out into the world to become a crack salesman for a New Jersey firm. And Bickel, with a National City Bank scholarship, became an actor.

He steps off the movie sets today and talks about it: "I was graduated from the University of Wisconsin. Commerce. Won some sort of contest given by Frank Vanderlip for young men with banking ambitions. Went to New York to learn to bank, at which precise time Mr. Vanderlip resigned and Mr. Stillman took over. Mr. Stillman had other ideas about young men. And I found myself with an idle Summer on my hands and thoughts of what I then discovered to be my first love, the stage, doing odd things in my mind."

Perhaps he climbed the historic flight of stairs to the Belasco "throne room," a flight mounted so often by Jeanne Eagels, with whom he played in her last movie, "Jealousy." More likely not, for his first part in "Dubureau" was small. In 1924 March was playing the lead in Gilbert Emery's "Tarnish." In 1926 he wrote the Wisconsin Alumni Records office that after playing leads in stock in Denver he had been engaged for Charles Hopkins' new show, "The Devil and the Cheese." The Theatre Guild engagement followed. His Tony Cavendish in "The Royal Family" won the admiration of John Barrymore when he played in Los Angeles. Even more, it brought him a Paramount contract.

A year ago Fredric March sent the Wisconsin Union $100 for a life membership. It was the sign that he had been released from the uncertainties of the decaying stage and entrenched in the pay checks of Hollywood.

THESE have been flash-backs on Fredric March, who as Fred McIntyre Bickel made history at the University of Wisconsin. For, to focus the camera on those old badger days is to see a strong, youthful personality, a quiet capacity and courage for work lodged in one person and bringing to him campus fame. And to focus the cameras for these flashblacks is to catch a newsreel panorama of the heyday of college dramatics before the war, the hectic period of student war days, and finally the first renaissance of silent pictures and the broken hearts which followed in its wake.

Fredric March's simple statement, "I was graduated from the University of Wisconsin," is too modest. In the Wisconsin year-books of late he has been listed as one of Wisconsin's distinguished alumni along with Charles A. Lindbergh, Zona Gale, Honoré Willsie Morrow, James Muir, and others.

And if he ever plays a college picture, the Wisconsin varsity boys are hoping that, remembering old Main Hall and Room 165, where he practiced to win the Freshman Dec—rooms today still as ugly, barren, and business-like as they were then—he will make a few changes in the lavish, expensive college sets which his unaccustomed directors may have planned.

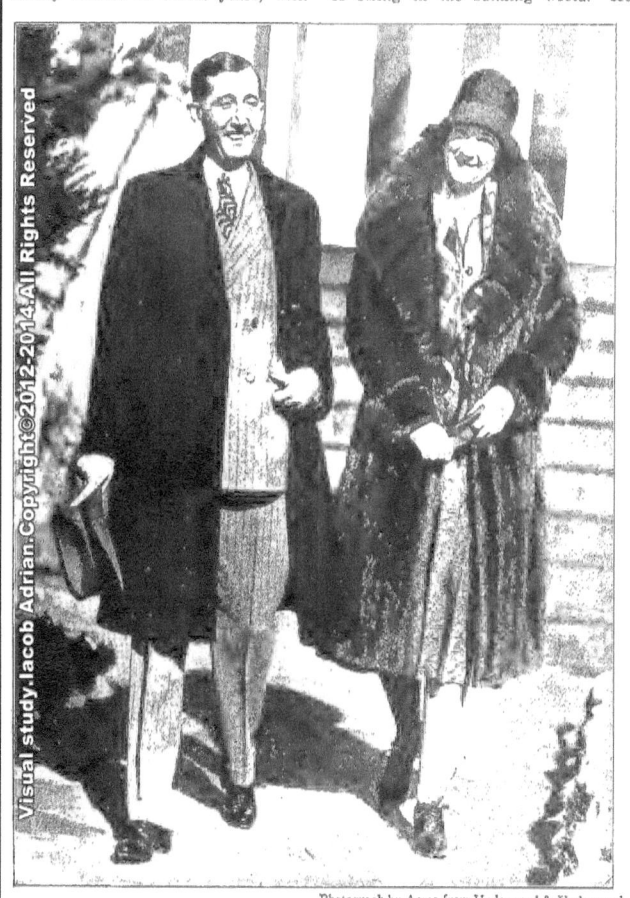

Photograph by Acme from Underwood & Underwood

Will Hays and his bride, the former Mrs. Jesse Stuttesman. This picture was made at Hot Springs, Va., where Mr. Hays and his bride were honeymooning recently.

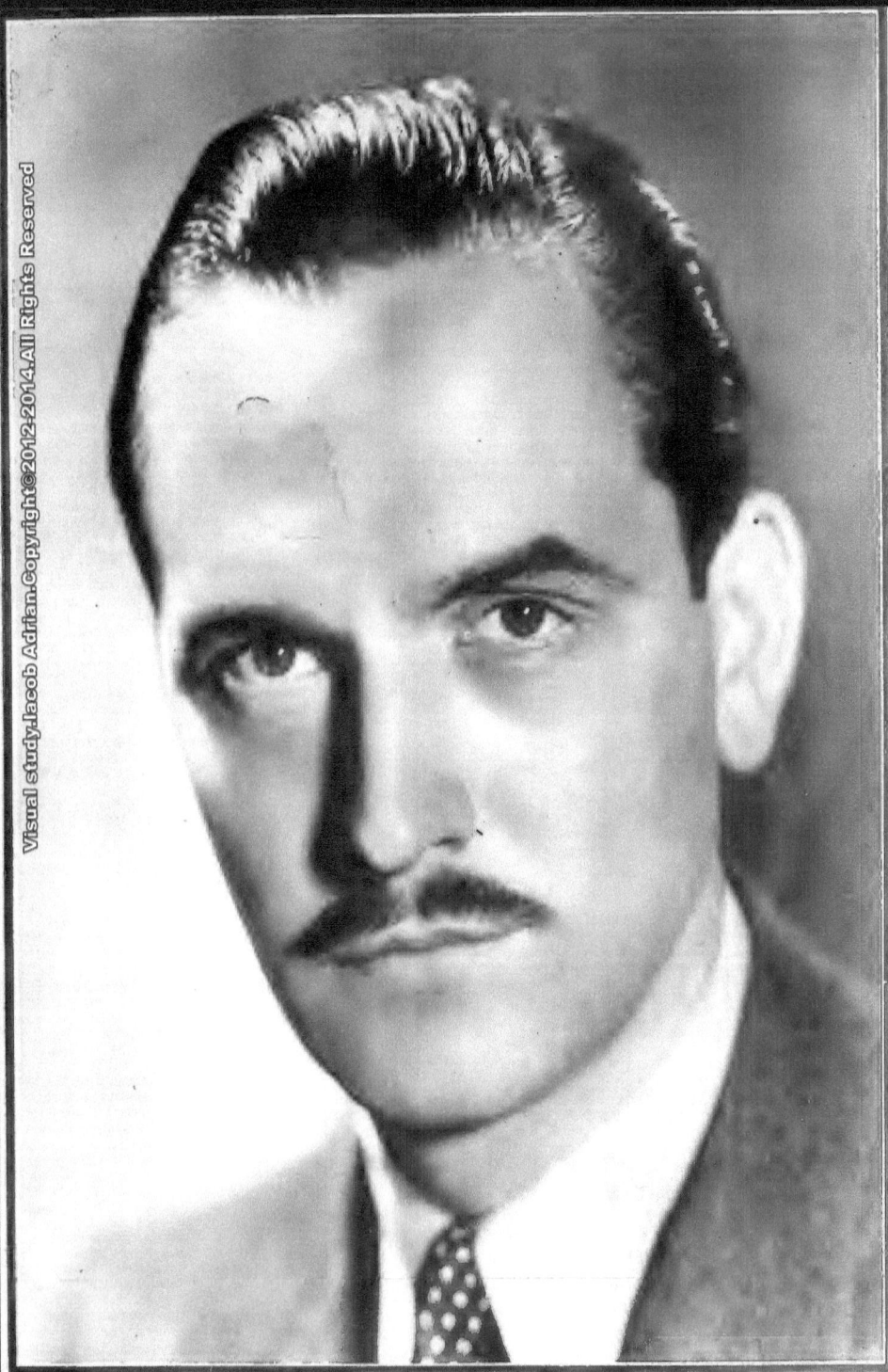

FREDRIC MARCH

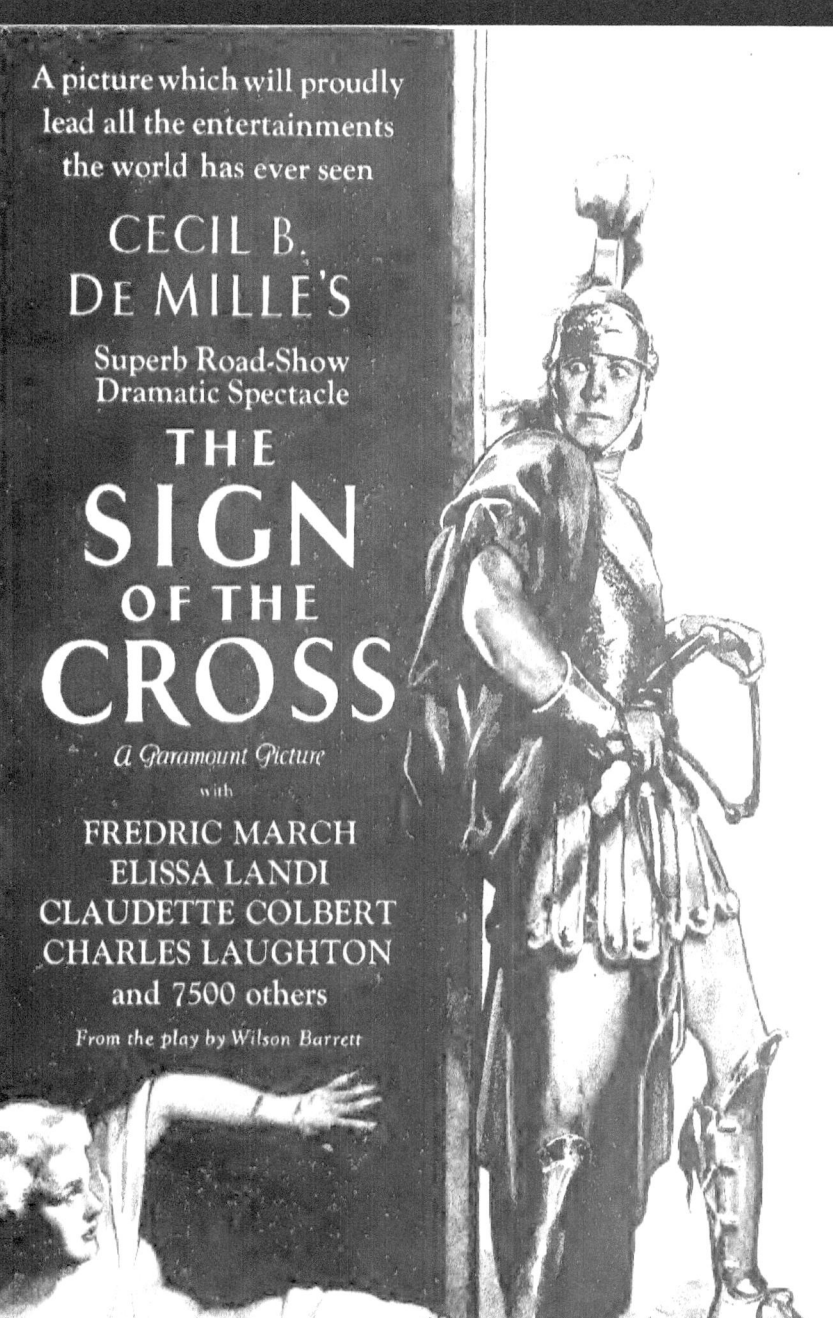

Ancient Rome lives again in barbaric splendor in her fierc[e]

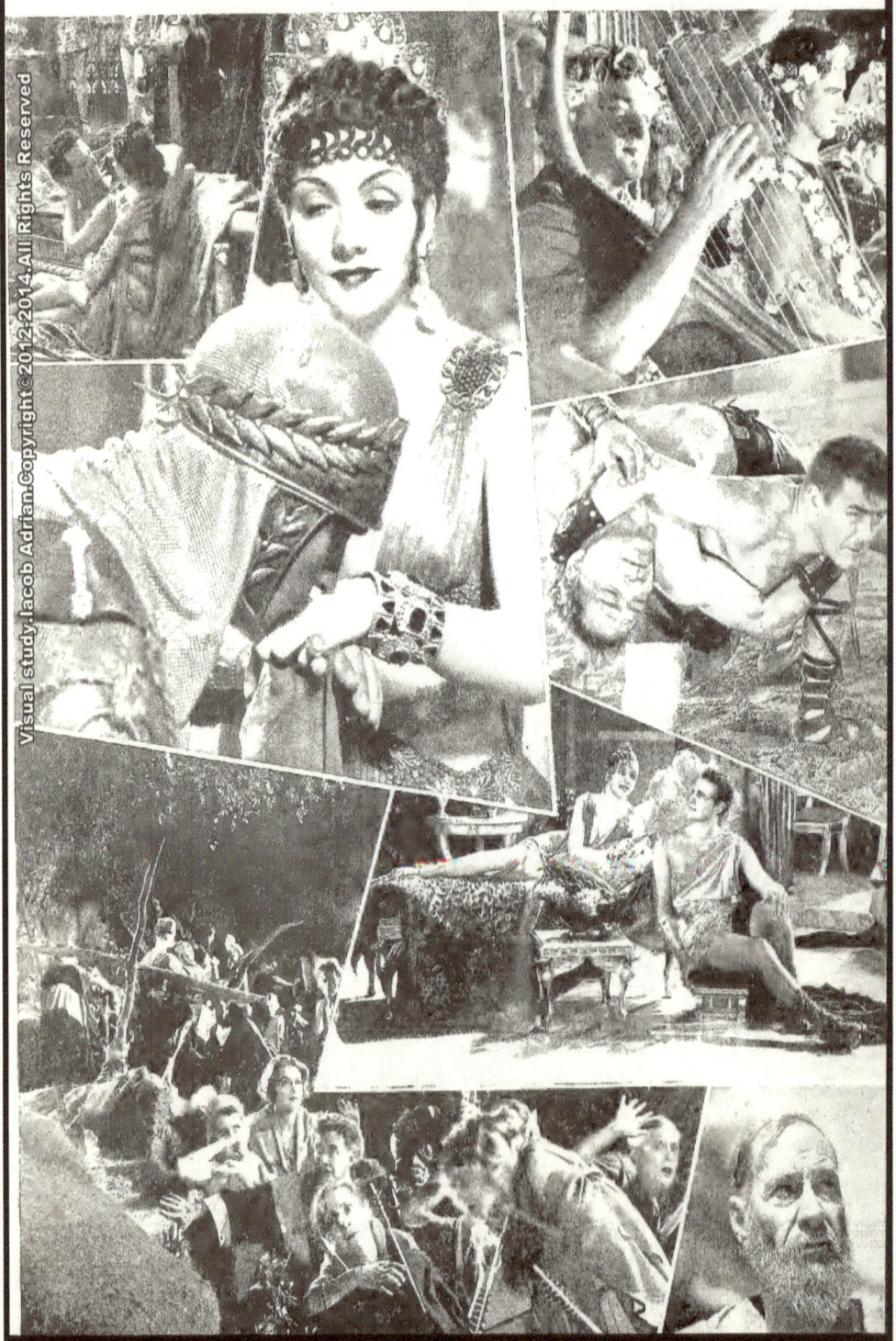

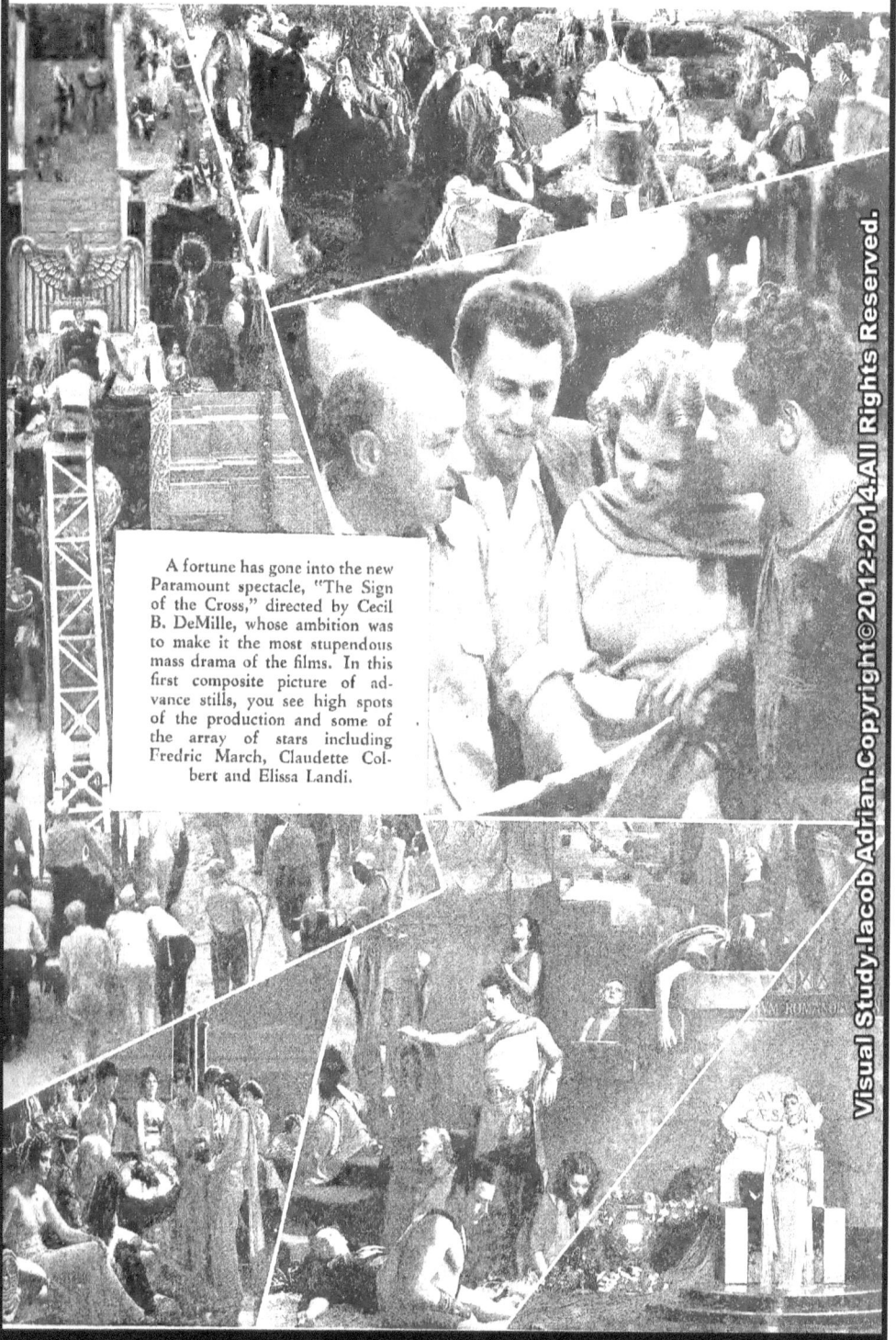

Fredric March, Hollywood Prince of Good Fellows, democratic, gay, fun-loving, unimpressed by the Academy distinction of 1932's best actor. "Luck," he says, "plus a good part. No actor is better than his rôle." Be sure to watch for him in his next, "The Eagle and the Hawk."

ELSIE JANIS sounds the new Hollywood cry—

Forward! MARCH!

WHEN you see Fredric March as *Marcus Superbus* in "The Sign of the Cross," you see more of him than usual, and very nice, too!

Freddy, in that chic black velvet costume with his slick black hair curled *a la* Norma Shearer looks like the sign of a cross between *Romeo* and a Follies girl. I know he has a lot of the former; any dash of the latter is purely photographic.

As you watch him, strong jaw set and eyes flashing, cracking his prefectorial whip over the shoulders of wrangling Romans, take it from me that if Freddy had his way every crack of the whip would be a wise-crack! I'm sure he goes to bed at night with a *bon mot* leaping through his thin and well-chiseled lips.

I have a feeling that he sleeps well, is hard to waken, and that once awake, the theme song, "Let's Have a Repartee!" begins. Whatever he does is evidently pleasing.

He and Florence Eldridge have been married over five years and they don't bother to remind you how happy they are. You're supposed to know that! Out here when any couple that has been married over a year starts talking about how perfect home life is, you can be pretty sure that the ink on the divorce decree is drying rapidly.

THE first time I heard of Fredric March, was right here in Hollywood, playing in that classic of the modern theater, "The Royal Family."

Everyone was raving over his performance and saying, "Why, you'd think it was John Barrymore himself!" Having heard this same phrase used about my own imitation of the younger Barrymore, I was not only interested but a bit green-eyed.

I went, I saw, and he conquered!

It was a superb performance, not entirely due to the fact that Freddy had caught most of the tricks. I especially avoid the word mannerisms, because the Barrymore knows his tricks and can drop the whole box at will. Freddy managed to combine Barrymore with March, and in my own opinion, with one eye on March's future, succeeded in exuding a great deal of

Miss Janis and Mr. March having luncheon together in the Paramount commissary. "I realized that apparently young March soft-pedals on publicity pictures with the weaker sex, and I, heaven help me, must not only be considered strong but safe."

Florence Eldridge (Mrs. March). They've been married more than five years and they don't have to remind you how happy they are.

his own charm into the impersonation of Jack—beg pardon, John.

Of course, one big success like the one March made in Hollywood and producers, who have been saying for months that an actor is not the type for pictures, will line up and fight for his signature on the dotted line. The next procedure is to cast the actor in a rôle just as far removed from the one in which he has made a hit as they can find.

Freddy, who is at heart a light comedian, but at head a good enough actor to play anything from *Uncle Tom* to *Lord Fauntleroy*, has done just about that. I mean comparatively and from a versatility angle.

He finally wound up his four years of broad jumping from melodrama to comedy and back again by winning the Academy award for the best acting of 1932, in the dual rôle of *Doctor Jekyll* and *Mr. Hyde*.

No doubt his early experience in banking helped his characterization a bit and he certainly deserved the award, but as there are so many faces which should spend half the picture hidden behind trick make-ups, why disguise fresh-faced Freddy? I for one hope he will stay out from behind beards and waving teeth.

AFTER seeing him in his last three films, I've decided that his is one of the nicest faces on the screen today and if he lets them hang it in hirsute trimmings again, I shall know he is getting a "cut" of the make-up man's makings!

I met Freddy first at a party where I had consistently refused to dance all evening.

Someone presented young man March and I sud-

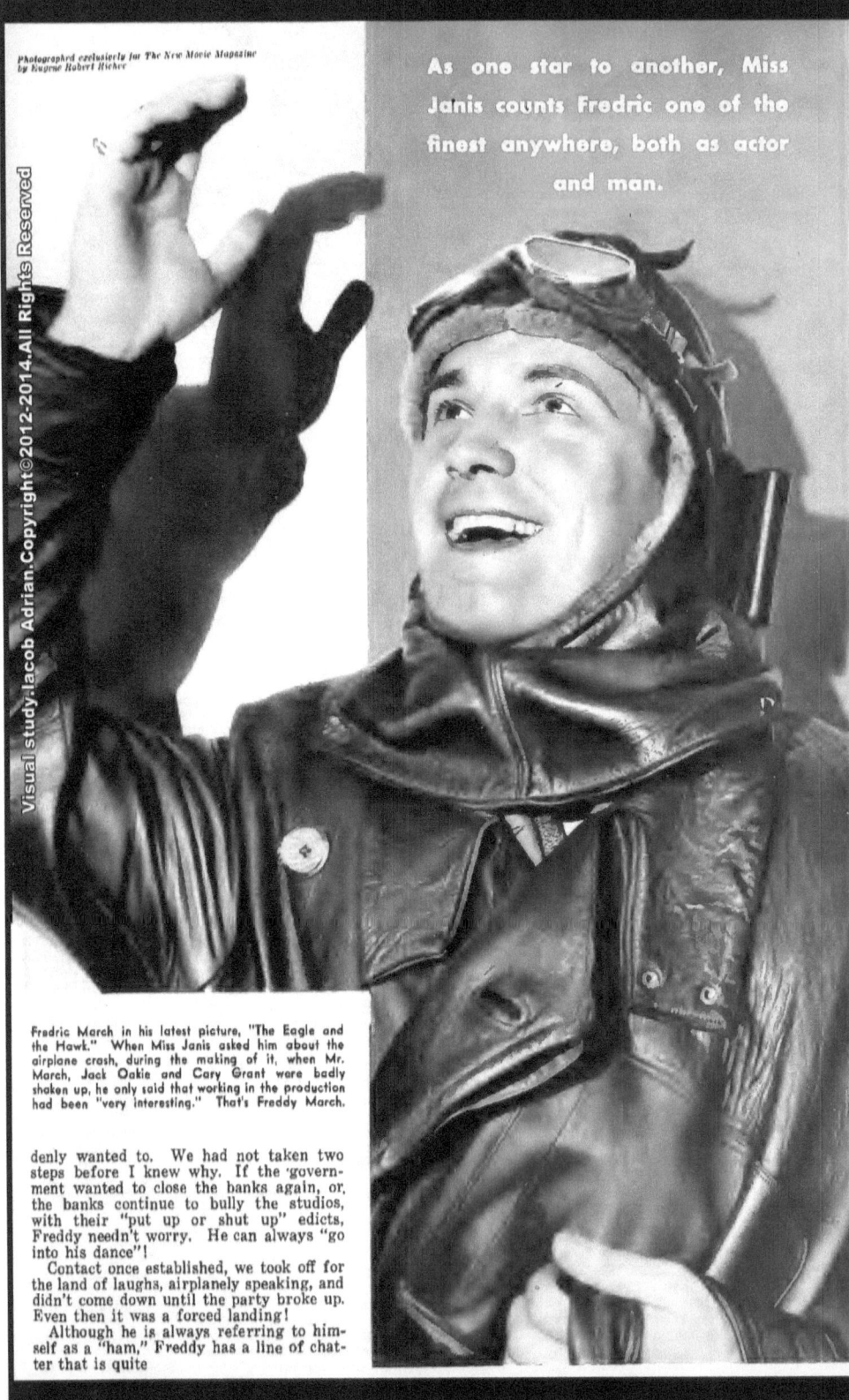

Photographed exclusively for The New Movie Magazine by Eugene Robert Richee

As one star to another, Miss Janis counts Fredric one of the finest anywhere, both as actor and man.

Fredric March in his latest picture, "The Eagle and the Hawk." When Miss Janis asked him about the airplane crash, during the making of it, when Mr. March, Jack Oakie and Cary Grant were badly shaken up, he only said that working in the production had been "very interesting." That's Freddy March.

denly wanted to. We had not taken two steps before I knew why. If the government wanted to close the banks again, or, the banks continue to bully the studios, with their "put up or shut up" edicts, Freddy needn't worry. He can always "go into his dance"!

Contact once established, we took off for the land of laughs, airplanely speaking, and didn't come down until the party broke up. Even then it was a forced landing!

Although he is always referring to himself as a "ham," Freddy has a line of chatter that is quite

Forward March

untheatrical. That evening he might have been just any nice guy with a devastating sense of the ridiculous shaking a wicked pair of pedal extremities.

The next time we met was at the studio when I was supervising "Paramount on Parade." If you honor me by reading these articles every month you will have grown weary of my constant reference to that revue, and you'll think it is the only parade I ever saw. This is not quite the case, but as practically half the stars in Hollywood were in it and I did make friendships or develop them through that association, I enjoy going back mentally to what were decidedly the "good old days."

Freddy, like the rest of the dramatic stars at Paramount, was highly amused at the idea of being in a revue.

"Couldn't you write something, a sketch or a number where I can play a tough, wise-cracking egg?" he said to me. I immediately suggested him for the leading "leatherneck" in a little playlet which Ruth Chatterton called "My Marine."

"March is the romantic type," my co-producers argued.

"If you don't think there is romance in the Marines ask the girls in all those ports," I said.

Freddy was so attractive at rehearsals that even before the revue was released he was cast as a gob with Clara Bow in "True to the Navy." As I write he is playing a flyer in "The Eagle and the Hawk."

I WENT down to lunch with him at the studio the other day. (This writing game certainly is a real meal ticket. Honestly, I used to eat before I started to pound a typewriter for a living, but I didn't consider it anything to write home about.)

Before we sat down, Freddy said, "Come and say hello to Florence. She is lunching here."

I said hello to Mrs. March, made some trite remark about borrowing her husband for lunch, and Freddy having proved that his husband complex was in good working order, led me to a table for two.

Even the studio camera man came to take a picture of us. I realized that apparently young March soft-pedals on publicity pictures with the weaker sex, and I, heaven help me, must be considered not only strong but safe.

During lunch we talked a lot about nothing. Freddy was most anxious to contribute any information that I might need, but I'm a skater on thin ice, not a deep-sea diver, so we just laughed our way through some Hungarian goulash.

Our hero has one weakness which I would like to discuss with Doctor Freud—he is a snipper-out of newspaper errors. Not only does he buy several papers a day to snip at, but he sends his findings to *The New Yorker* and gets them two dollars if they happen to be funny and decent at the same time.

He told me several which I'm sure even the sophisticated *New Yorker* couldn't handle and I blush to admit he has started me on a career of collecting typographical errors.

"We discussed the late earthquake. When I say late, as far as I'm concerned it arrived in plenty of time, and though it is now as forgotten as the republican party I still get a kick out of who was where for the big shakedown.

Freddy was lighting a cigarette for Sari Maritza on a set other than his own where he had gone just to have a little fun and relaxation between scenes of his high-flying picture.

"I struck the match," he said, "and leaned forward. Miss Maritza suddenly seemed to be leaning back. The match went out and with it a lot of lights. Some one yelled 'Earthquake!' and the building seconded the motion. By the time we got out, the show was over and I prepared to return to my own set.

"Reports began arriving about the damage at Compton and Long Beach. I have to pass through both of them to get to Laguna Beach where Florence and the kid were. Over the radio we heard that both towns were laid flat. No mention of Laguna.

"Well! I put in a call for Florence. Telephone communications were nil."

Young March was saying it lightly, but I'm pretty sure that he was playing our latest and most popular Earthquake Game, which everyone, myself included, enters saying, "Well! it was the funniest thing. I was—" and so on. If the microphone was dependent upon the laughs it recorded during those twenty years which were really seconds, while this part of the world seemed to be trying to shake loose from the bankers, poor old "Mike" would be among the unemployed.

THE more important Mr. March, who wins Academy awards and is called upon to address that active organization in times of stress, the more serious Freddy who for no reason I can fathom (outside of the fact that he can combine acting and tact), has been made President of the Mayfair Club, a difficult job and in pre-March days always held by an executorial big shot, was slated to talk to a gathering of actors that night. His subject was "To Cut or Not to Cut! That is the Question?"

When he couldn't get Mrs. March on the phone he said, "Cuts or no cuts, I'm going to Laguna," sent for his car and was just about to take a fifty-mile ride when the Missus managed to get word to him that she and the little girl were all right. So he went to the meeting.

All that evening we had slight reshakes and when at about 10:00 P.M. Freddy started to light a cigarette, a regular one interfered, so he claims quake credit.

I claim the same, for I had just begun to rehearse at a local broadcasting station when the big one arrived, at the sound of my singing voice, as it were. That night I had just started to broadcast when I had to grab the microphone, which appeared to be falling for me, and the building gave every indication of following suit. So Freddy has agreed not to light any cigarettes if I'll promise not to sing. Perhaps its just as well for everybody concerned.

Mother Earth was still shrugging her shoulders now and then a few days later when an airplane which was supposed to fall to pieces as Freddy, Cary

Forward March

Grant and Jack Oakie stepped out of danger got a bit over-anxious and went boom ahead of time. Cary Grant was burned, Oakie badly shaken up and as for Freddy, when I asked him if he had enjoyed making "The Eagle and the Hawk," his answer was, "It's been very interesting!" but his eyes said plainly, "I suppose it's just naturally a woman's privilege to ask darn fool questions!"

IT seems to me that his most outstanding quality is his humanness. Maybe I made that word up, but if I did I dedicate it to Freddy. He is absolutely down to earth and the earth's a swell place!

He wouldn't know a platitude if one slapped him in the face, but he would slap back with a gag or wisecrack. He doesn't seem to have any particular plan of attack on life or any great ambition, which so many people have to such an extent that they will wish it on you even if you only ask what time it is.

He doesn't know what his next picture will be; he isn't demanding to play this part or refusing to play that one. I especially did not ask what he thought about the much-discussed salary cuts because if he has a "hire a hall and tell the execs where they get off" attitude hidden under his wealth of versatility, I didn't want to see him assume it.

I was having too good a time with the snipper-out of newspaper errors in person; and, besides, I'm so tired of listening to talk about salaries that at the head of my list of things to be thankful for goes the fact that I am not on a studio payroll.

WE discussed "Tonight is Ours" in which I thought he was splendid. "Too much make-up!" was his self-criticism.

"I didn't notice it," I answered.

"Well, that's nice of you to say so, but I jumped right from that old Roman number with paint and curls into 'Tonight is Ours' and I didn't realize how big the leap was, I guess. A lot of people picked on it after it was all finished, but while we were shooting, it was a case of even his best friends wouldn't tell him."

It may be that I bring the vernacular out in folks, because I've given up several languages in its favor, but Freddy uses a lot of slang and swears pleasantly, more to punctuate than impress. It is possible that he is trying to live down a lot of publicity anent his activities while in college—head of his class, Alpha Delta Phi, class orator, refused to appear in college plays as a girl and joined the dramatic society instead.

I've read all these things and am sure they are true, but the March of Freddy, like that of Time, goes ahead and the vision broadens. Today I can't imagine his refusing to play the hind legs of a phoney horse if he thought he could do it and was needed.

I'm sure he could orate if he thought a subject worth the effort.

I know he could play a great *Hamlet*, but why depress people when they are just beginning to cheer up!

I, personally, hope that the March I'm a booster for will just keep on laughing and snipping out errors. I'm backing him not to make any himself. The command is: "Forward! March!"

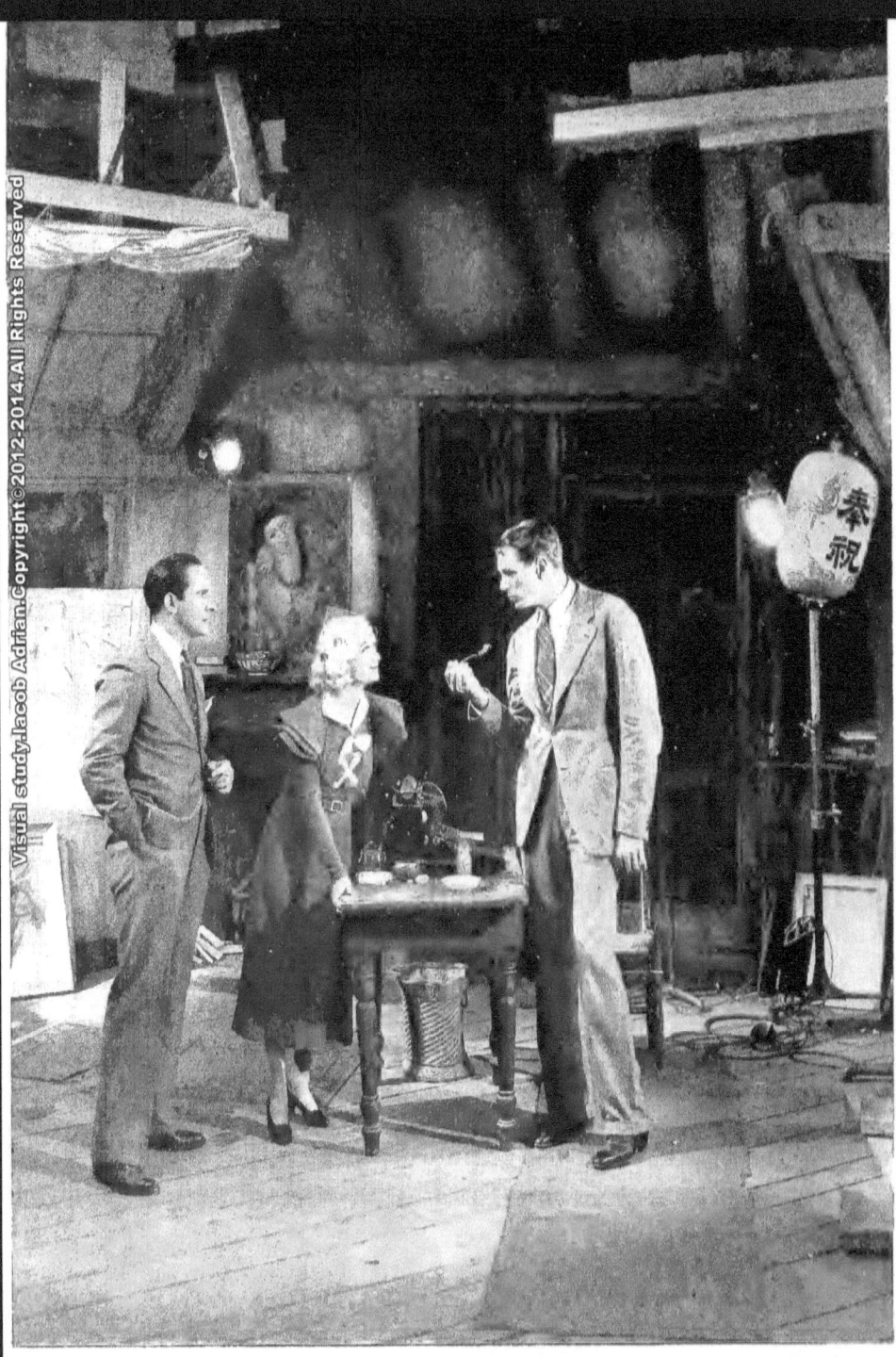

DESIGN FOR LIVING

Re-designed slightly by Herr Ernst Lubitsch himself, and with the added "Lubitsch touch," Noel Caward's smashing stage success, "Design for Living," appears as one of Paramount's most ambitious offerings of the season. Fredric March plays *Tom*, the playwright, done on the stage by Mr. Caward himself, Gary Cooper plays *George*, the artist, played on the stage by Alfred Lunt, and Miriam Hopkins is *Gilda*, played on the stage by Lynn Fontanne.

Edward Everett Horton plays *Max*, who finally marries *Gilda*, only to have her lured away again by *Tom* and *George*, and Franklin Pangborn is *Mr. Douglas*. In all fairness to Mr. Lubitsch, let us add that the various changes were made mainly to appease the censors.

One interesting speculation is how the public will accept Gary in a type of part so completely different from anything he has ever attempted.

Pictured above, in a photograph especially posed for The New Movie Magazine, you see Freddie March, Miriam and Gary in one of the brilliantly dialogued scenes in the Paris apartment which the three occupy. At the right is Director Lubitsch, surrounded by his staff.

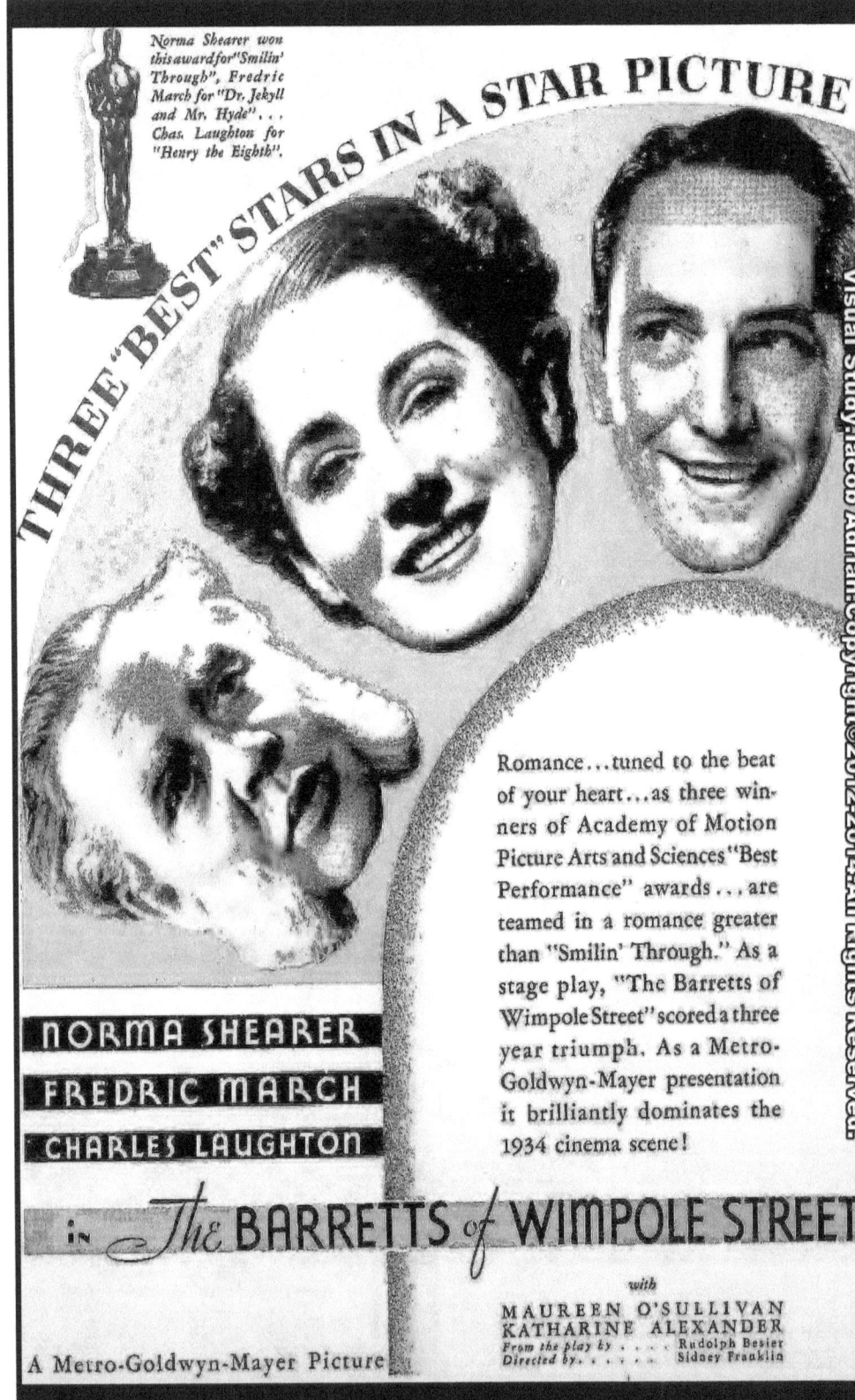

Bibliographic sources :

Hollywood (1934-1943)
Publisher: Hollywood Magazine, inc. ; Fawcett Publications, inc.

The New Movie Magazine (1929-1935)
Publisher: Tower Magazines, inc.

This documentary study use,
combined in various proportions,
elements from the following categories,
forms and subsets :
- fair use
- documentary
- documentary photography
- feature
- journalism
- arts journalism
- visual journalism
- photojournalism
- celebrity photography
in order to :
- employ material as the object of cultural critique ,
- quote to illustrate an argument or point ,
- use material in historical sequence,
providing independent opinion,
using photos, press articles, advertisements,
opinions of fans etc. ...

Copyright©2012-2014 Iacob Adrian.All Rights Reserved.

www.ingramcontent.com/pod-product-compliance
Lightning Source LLC
Chambersburg PA
CBHW021044180526
45163CB00005B/2277